Master Class

ROBERT SCOTT LAUDER AND HI

15 JULY TO 2 OCTOBER
NATIONAL GALLERY OF SCOTLAND

15 OCTOBER TO 12 NOVEMBER
ABERDEEN ART GALLERY
(*selected works*)

1983

This exhibition is made possible by the generous support of
SCOTTISH & NEWCASTLE BREWERIES plc
incorporating Scottish Brewers Ltd; The Newcastle Breweries Ltd;
McEwan-Younger Ltd; William Younger and Company Ltd;
The Waverley Group Ltd; and Thistle Hotels Ltd

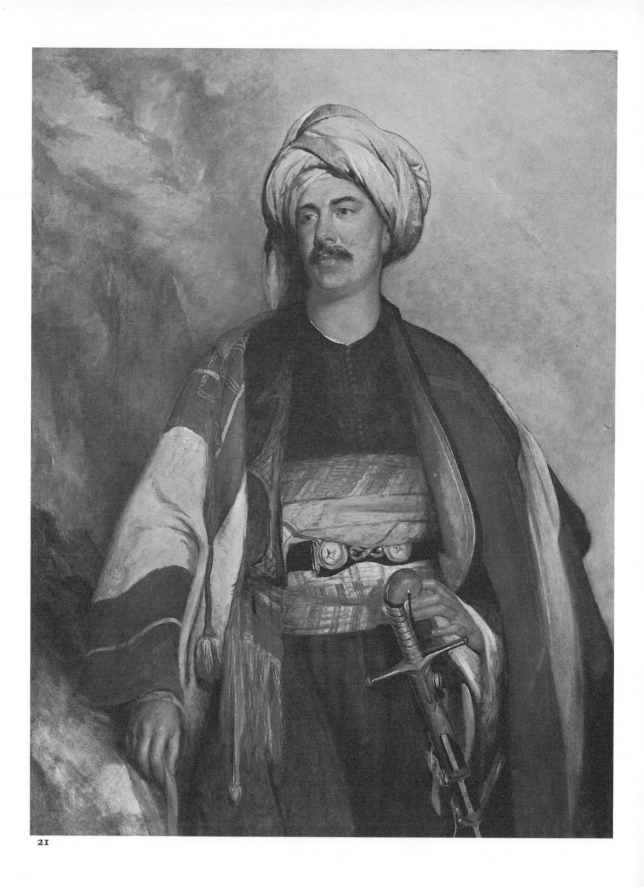

21

Master Class

Robert Scott Lauder
and his pupils

LINDSAY ERRINGTON

NATIONAL GALLERIES OF SCOTLAND

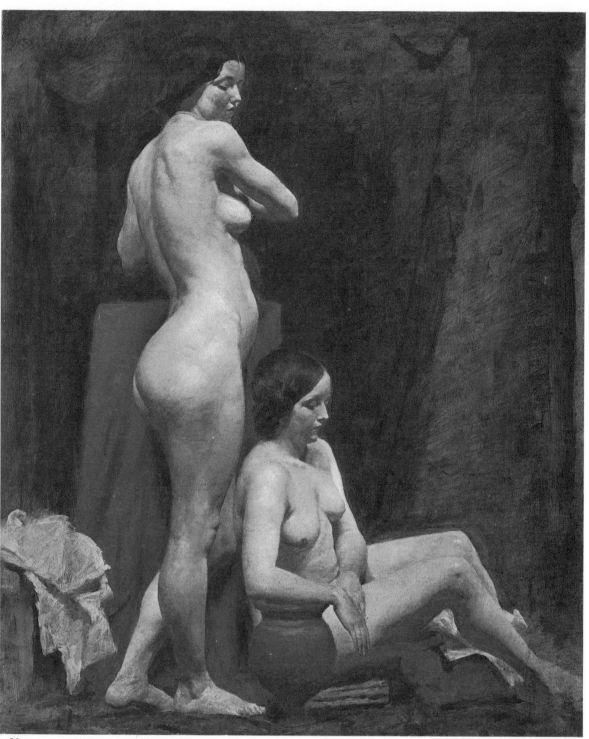

39

III detail

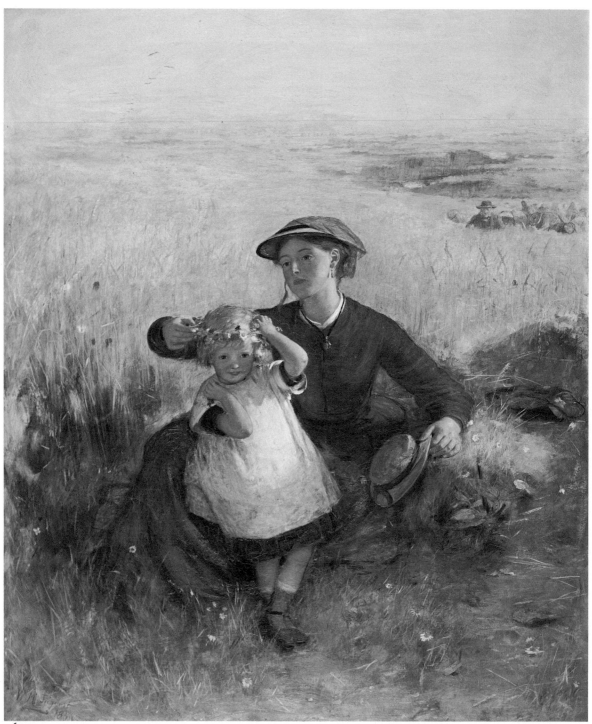

Contents

Foreword

Those who know about Scottish painting possibly associate the name of Robert Scott Lauder (1803–69) with one particularly good portrait, that of his brother Henry in the National Gallery of Scotland. He is also remembered as a teacher although we do not perhaps appreciate the full extent of his influence in this role as certain artists did who were his pupils during the time Lauder was Director of the Trustees' Academy in Edinburgh. McTaggart, Pettie, Orchardson and Chalmers never forgot the debt they owed to him. Lauder's teaching and influence on these pupils, their development as artists in Edinburgh and London, are the subject of the present exhibition.

We are deeply grateful to Scottish & Newcastle Breweries plc for a generous subvention towards the costs of this exhibition; and we would like to record our thanks in particular to Mr Peter Balfour, Chairman, and Sir Hew Hamilton-Dalrymple, a member of the Board, for their enthusiastic support. We hope the exhibition will be enjoyed by a wide range of visitors both here and in Aberdeen where part of it will be shown after it has closed in Edinburgh. It contains something for everybody with an interest in Scottish painting, from the inventive subject pictures of Orchardson and Pettie, now overdue for re-assessment, to the luminous late landscapes of McTaggart. The exhibition should have a vigorous after-life in Lindsay Errington's catalogue which is both an original contribution to the study of Scottish painting and an important addition to the literature on the history of academies of art.

We wish to thank Her Majesty The Queen for graciously allowing us to show Pettie's *Bonnie Prince Charlie entering the ballroom at Holyrood* from Holyrood Palace. We are also grateful to all other lenders, particularly private owners: Her Grace The Duchess of Buccleuch; the Honourable Alan Clark, MP; Mr and Mrs Richard Emerson; Dr Duncan MacMillan; the Trustees of Miss Barbra McTaggart; Mrs E.F.McTaggart; the Trustees of Miss Jean McTaggart; Mr and Mrs Robert Nilsson; Mr Andrew McIntosh Patrick; Mrs M.Vaughan; and all those lenders who wish to remain anonymous.

Hugh Macandrew, *Keeper*

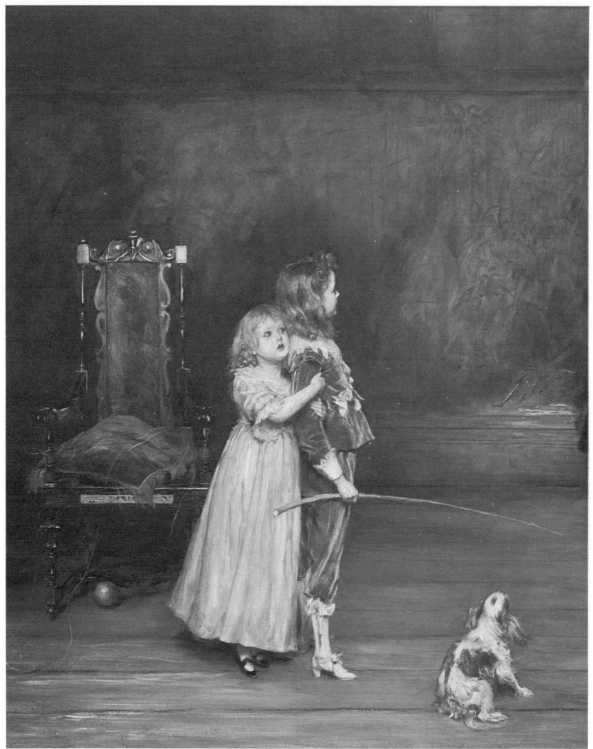

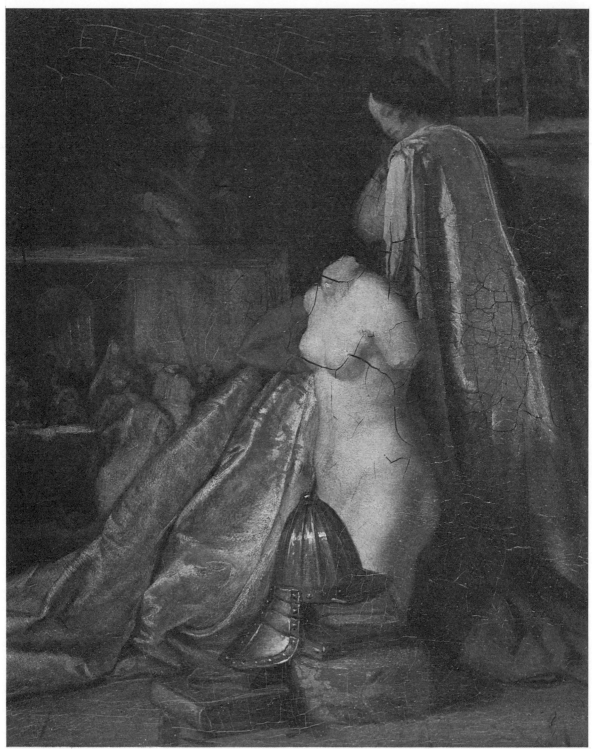

Master Class:
Robert Scott Lauder
and his pupils

THE ART OF ANY country is necessarily conditioned by the way its artists have been taught. The transmission of ideas and craft practices from one generation of artists to the next constitutes the artistic tradition which makes the painting of any one country carry a clearly marked national stamp. In the creation of such a national style abstract theories and the written word seem to count for far less than personal example. A visual tradition is transmitted visually and by means of the personal conviction and enthusiasm of its practitioners. Scottish art shows only a few characteristics to distinguish it from English art before the 1860s, when the works of such painters as McTaggart, Orchardson, Pettie, and Chalmers began to appear in public exhibitions. The English painter Sickert who had modelled his own narrative painting upon French Impressionist work but was nevertheless well able to understand and value an alternative tradition of narrative art, wrote with appreciation of 'the admirable Rubens – Wilkie – Orchardson tradition of execution'. In Sickert's chain there is a missing link, the name of a painter probably unknown to him but without whose intervention the tradition of Rubens and Wilkie would not have been passed on at all. This painter was Robert Scott Lauder. In Scotland itself he has always been known and valued as a teacher, but the emphasis on his teaching has led to his own paintings being discounted or forgotten. His pupils did not make this mistake. They admired his painting as much as they respected his teaching and for them the first validated the truth of the second. In this essay, as in the accompanying exhibition, an attempt is made to re-establish Lauder as a painter worth looking at, and to show exactly how he himself was taught, and which of his own practices and values he was able to pass on, and how.

Robert Scott Lauder was born on 25 June 1803. The Edinburgh into which he was born contained very few facilities for artists, and very few artists of any real quality. There were no public exhibitions of the works of living painters and no public buildings in which national collections of the works of old master or modern painters might be seen. The twin temples of art that now dominate the Mound and with which Lauder was to be so closely associated, had not even been imagined. Surprisingly this city from which so many artists emigrated to England or Italy in order to survive, did possess one great advantage. There was a Drawing Academy, the first of its kind in the British Isles to be funded

1. Lauder's training at the Trustees' Academy and early years in Edinburgh

Lauder's birth. Artistic situation in Edinburgh

(9)

with public money. This Academy originated in a strange way. At the time of the Treaty of Union of 1705 the government made over a compensatory £2,000 to be employed in encouraging the wool and fishing industries and general improvements in Scotland. Twenty-one Trustees were appointed to supervise the expenditure of the money. In 1760 the Board of Trustees decided to open a drawing school in which young people 'of both sexes' were to be trained to design for manufactures. This was the beginning of the Trustees' Academy. As an establishment it consisted at first of one master, two rooms belonging to the University and probably some meagre equipment such as a few engravings and some small plaster casts of architectural ornaments. Although the Trustees' object was to train designers of carpets or damask table linen rather than fine artists, in the long run their purpose was defeated by three factors. Artists were invariably employed as masters; at that date no theory existed for training specialist designers by methods distinct from those used to train artists; no other academy for teaching fine art existed in Edinburgh and so a fair proportion of students entering the school were intending painters.

One of the Trustees described the Academy in 1803 as 'small and confined and situated in a common stair. . . . Down to this period it had been a kind of Elementary School for pupils intending to become professional artists.' Its chief assets were the plaster casts of antique Graeco-Roman sculpture which the Board had begun to collect in 1798. Initially the cast collection had been so limited that the master Alexander Runciman is said to have turned a (miniature) copy of the Laocoon group upside down in his rage with a student who pleaded for a new model. The casts were important because normal academic training for art students at that period consisted in a progression from drawing the human body as represented in classical sculpture to drawing the living body, and technically from drawing to painting. Antique sculpture was not used in the early stages for cheapness, convenience, or because the students found it easier to draw, but as an instrument to develop their taste for beautiful forms. Therefore it preceded drawing from the living nude, since many of the people available as models to pose in academies were not beautiful at all. The practical possibilities of carrying out such a theory of training in countries far removed from Italy depended absolutely on a supply of plaster casts of those sculptures which by general agreement were held to be supreme examples of beauty. Colour apart, a good plaster cast is virtually the original work of art. These casts were neither cheap to make nor easy to transport, but during the first third of the nineteenth century the Trustees were regularly paying out large sums of money for box loads of casts to be carried from Paris, Leghorn and Rome, where their agents were on the lookout for new subjects to acquire. An example of the high cost can be seen in the accounts for 1816, the year in which the Academy obtained casts of four pieces of the recently arrived Elgin Marbles. At that date the annual cost of running the whole school was in the region of £420, but the return made for 1816 shows an expenditure of almost double the amount, the extra £395 having almost certainly been paid for the casts.

The Academy that Lauder was to enter as a pupil in the 1820s was

thus far better equipped than it had been in 1803 – when Wilkie was attending it – but it was still only an elementary school because the second essential leg of training, drawing from 'the life' was missing. Any artist who wanted to complete his education was thus compelled like Wilkie, and later Lauder himself, to go to London. The deficiency tended to perpetuate itself in a vicious circle as Trustees-trained pupils returned there to teach, and it must account for certain weaknesses of drawing exhibited in even the best Scottish painting during the first half of the century, as well as partly explaining why Scottish artists should have found it difficult to hold their own against English artists who had received a more thorough training.

Deficiencies in training at the Trustees' Academy

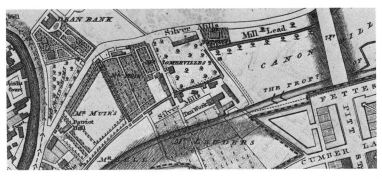

a) Robert Kirkwood's 1817 plan of Edinburgh, showing the Lauder property at Silvermills. (*detail*)

Robert Scott Lauder's father, John Lauder, owned a tannery business in Silvermills. He possessed a fairly extensive, irregular wedge of ground bounded by what are now Henderson Row on the north, East Silvermills Lane on the east, and Clarence Street on the west. At its southern end his property included the area on which St Stephen's Church now stands. The dwelling house was an old one vaguely described by a later writer as 'a pleasing specimen of old Scottish domestic architecture'. It was fronted by a formal garden with straight walks and rows of trees. John Lauder was obviously a prosperous man living in pleasant surroundings, but by the end of the century increased factory development had rendered the area squalid, depressed, and smelly. The elder Lauder had no artistic interests and wanted his son to follow him in the tanning business. When Robert left the High School he was put into the counting house of the tannery with marked lack of success. It is also said he went into the firm of drapers (also Lauder) in the High Street, but only distinguished himself by the 'superior style' in which he addressed the parcels. Three factors had acted to rouse the boy's interest in a career as an artist. His imagination had been kindled by an illustrated book of *The Arabian Nights* – probably the edition with Smirke's illustrations which acted in a similar way on Leitch in Glasgow. He had seen specimens of modern painting shown by the Associated Artists whose exhibitions began in 1808 and were discontinued in 1816, and which were held in Raeburn's Gallery from 1809 until 1816. Lastly, and most important perhaps of all, he had met and struck up a friendship with David Roberts who was slightly older than himself. This friendship may have com-

Lauder's home background

Friendship with David Roberts

menced about 1818 when Roberts was painting scenery for the theatres in Glasgow and Edinburgh. It was to be nearly life long, though soured at the end by sums of money Roberts lent Lauder and which were never repaid.

Lauder enters the Trustees' Academy

In 1822 Lauder's father finally withdrew his opposition to the idea of an artistic career for his son, and having done so supported him financially for many years with generous sums of money, which, Robert later ruefully declared, 'I heedlessly spent', – the management of money was always to be his problem. On the 11th June an application accompanied by specimen drawings (now lost) was sent to the Board of Trustees for admission to the Drawing Academy. In the formal language expected of such documents Lauder stated 'that your petitioner intends to pursue the business of Portrait Painting and wishing to enjoy the advantages of a well grounded Education prays to be admitted a pupil to the academy'. He gave his age as eighteen though he was in fact almost nineteen and relatively old for entry to the school. David Scott for instance, who had no parental opposition to break down, had entered at fourteen as an apprentice engraver to his father. When Lauder applied there were eight vacancies and fifteen applicants. He was fortunate enough to be accepted and was therefore secure for the two years which were the then prescribed length of the course. This brief period could be extended by application to the Board for a further year's teaching which was normally granted at the discretion of the Master. David Scott, for example, extended his time twice and was thus one of Lauder's fellow pupils. Others whose training overlapped with his were Andrew Sime and Robert Gibb. D. O. Hill had just finished.

b) Robert Scott. Drawings made at the Trustees' Academy under David Allan, showing outline drawing from 'the flat' and shaded drawing from 'the flat' as practised by the elementary students (see catalogue nos. 30 and 31).

Andrew Wilson was the Master. There are conflicting accounts of his usefulness. David Roberts, who spent precisely two weeks with him, was enormously impressed by the information – new to him – that nature contains no outlines, but was otherwise unimpressed. The English artist Rippingille who was introduced to him in London about 1814 found him disagreeable and secretive, unwilling to part with information or advice. Lauder, on the other hand, had a different story to tell. 'Many of the members of the RSA' he wrote to D. O. Hill in 1843, 'are much indebted to him, and of course you recollect with how much kindness he came to our studios and helped us to overcome many difficulties. Indeed all he could do he did'. That 'all', however well intentioned, may nevertheless not have been enough, since Wilson was a landscape painter ill-qualified to teach the drawing of the human figure, and his heart was evidently not in teaching, for he resigned from the job in 1826 and took himself and family off to Italy to work at painting 'as a hungry man would do who had been long in a state of starvation'. Lauder, when his two years were up presented no plea to stay on longer, and this in itself suggests that he felt he had exhausted what Wilson could offer.

The course was indeed an elementary one. A visitor entering the old Drawing Academy at Picardy Place would have seen, in rooms warmed with coal fires, and lit by candles, a number of boys or young men crowded together in accommodation that the Board itself frankly admitted was 'quite inadequate' for the students, let alone the boxloads of bulky casts

arriving once or twice a year from Leghorn and Rome – many of which seem to have been deposited for storage in the cellars of the Exchange. No painting or original composition would have been seen in progress by the visitor. This was not the purpose of the course. The elementary students would have been copying from 'the flat', that is, from engravings, or from drawings by previous masters. The more advanced students were permitted to go next door into the cast room and draw from 'the round'. Amongst these students, only some were intending fine artists. Others were coach and herald painters, engravers, cabinet makers, carpenters, or even 'damask pattern drawer' the intended profession of Joseph Neil (sic) Paton in 1823. Everyone, regardless of profession, would have been doing exactly the same work.

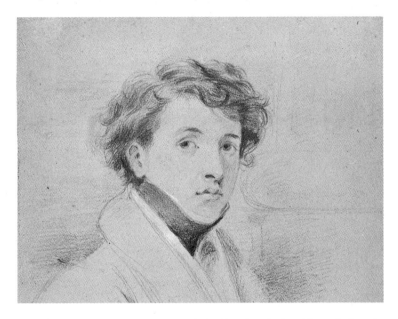

c) Robert Scott Lauder. Self portrait drawing of August 1823. (*detail*)

The only known drawing made by Lauder during his period at the Trustees' Academy is a small self-portrait dated 1823 (SNPG collection). It shows a youthful face inclining to prettiness, and thick curly hair. There is not yet a hint of the side whiskers which in due course were to encroach further and further over Lauder's face, until he became the benign and bearded patriarch of Hutchison's funerary bust. When his two years with the Trustees were complete, Lauder went to London to work from the life. Even there, opportunities were limited. Sass's well known school in Bloomsbury offered a very 'severe' version of the same sort of course Lauder had already undergone and the RA schools would not admit anyone to the life until he had done his stint in the antique. Lauder probably attended the St Martin's Lane Academy where the living model posed, and artists such as Etty went to draw. Otherwise he drew from the Elgin Marbles in the British Museum, and formed the deep and abiding love for them that caused him to make them the foundation

Lauder goes to London

Admiration for the Elgin Marbles

(13)

of his own later teaching. 'The Elgin Marbles which stand unregarded, alone, sublime, in a wicked and senseless world', as he described them in 1836, had probably a beneficial effect on his sense of beauty, grace and proportion. Traces of their influence can be seen again and again in paintings from all periods of his life, and they probably helped him avoid the grotesque and uncouth excesses of expression seen in the draughtsmanship of his contemporary David Scott, who had not experienced such saturation with Greek art.

Returns to Scotland

In February 1828 Lauder wrote to the Secretary of the Royal Institution in Edinburgh, thanking him for the honour of membership which he had just received. Lauder had returned to Scotland at some time between the summer of 1827 and the beginning of 1828, and was settled at 24 Fettes Row on the corner of his father's old property. The Royal Institution was the official exhibiting body which preceded the Royal Scottish Academy – founded in 1826 by artists dissatisfied with the high-handed treatment meted out to them by the Royal Institution. Initially William Allan, Steell, David Scott and Lauder himself – the better artists – all adhered to the Institution, till eventually in despair they too seceded in 1824 to the RSA.

William Allan succeeds Andrew Wilson. Trustees' Academy moves to the Royal Institution.

During Lauder's absence great changes and improvements had taken place at the Trustees' Academy. His friend William Allan had been appointed Master to succeed Wilson in March 1826, and the Academy itself had moved in the same year from its cramped quarters in Picardy Place into spacious new rooms in the Royal Institution building (now the RSA) on the Mound. The casts of antique sculpture were moved across in July, repainted, and remounted on new pedestals designed by Playfair. Some large pieces, the Laocoon, Apollo Belvedere and others had actually to be cut out of their former positions. New shiploads of casts from abroad continued to pour in via Leith.

New desks, shelves and drawing boards were ordered for the Institution building and the old ones were thoughtfully packed off for use at Dunfermline Drawing Academy. Other improvements followed. A year later it was proposed to light the new Drawing Academy with gas instead of candles, a piece of modernity that William Allan had investigated at the RA Schools in London. Allan also tried to persuade the Trustees that the standard two-year training period was too short 'for the requisition of correctness in drawing, and many students when the allotted two years expire are just beginning to feel how much they have to learn'. His plea met, unfortunately, with little response. More successful was his proposal that students should annually submit drawings for examination and that the best would receive small monetary prizes. This annual competition had grown by the time of Lauder's directorship into a major feature of the Academy year, with many different classes and prizes, but at the start it was a very modest affair. The course itself still consisted only of drawing from the flat and from casts. There was as yet

Lack of a 'life' school

no life school, though the Royal Institution commenced one in 1829 and promised to admit the Board of Trustees' students if the Royal Institution's portion of the rent for the shared building could be reduced – it was not!

(14)

ACADEMY AND EARLY YEARS IN EDINBURGH

Allan was a sociable and genial man, attentive to and much liked by his students. An old pupil of his recalled in 1862 that 'The style of drawing taught was also essentially different from what it has been for many years past (i.e. under Lauder), and confined almost entirely to the figure (i.e. the cast), the students copying from the flat until they obtained some mastery of outline, after which they were allowed to draw from the round. To obtain accuracy of outline was especially enforced, both by precept and example. This attained, you were at liberty to put in the shading by whatever method you chose; those who preferred hatching in line did so, and those who liked the broader method of working with the stump did accordingly. Sir William, however, preferred the latter, for the simple reason that it was done in shorter time, and that there was less danger of becoming mechanical than in working in line alone.' 'Stump' was a little device of leather or paper, now regarded with disapproval, which was used to smudge the shading on a drawing into an even tone. The drawings, now in the National Gallery of Scotland's collection, produced by William Bell Scott – who had entered the Academy in June 1827 – show what Allan expected. Two are nude studies – copies from other drawings – and there is also a highly finished stump drawing of Michelangelo's *Dead Christ* on grey paper. The figure of Christ is con-

Style of drawing taught by Allan

d) William Bell Scott. Drawing of a cast of Michelangelo's 'Dead Christ' made at the Trustees' Academy in 1827 (catalogue no. 33).

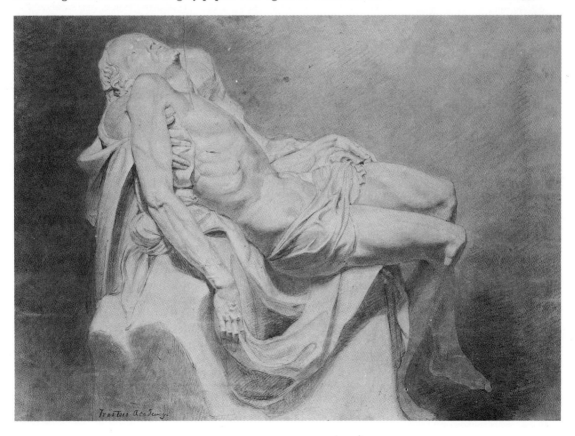

(15)

ceived in complete isolation as if it had not really been standing inside a room with walls and other surrounding objects. This is so unlike what Lauder later demanded of his students when drawing the antique that he clearly cannot have derived his teaching methods from Allan, close friends though they were.

Lauder stands in for Allan as Master of the Trustees' Academy

Allan suffered from poor health. In 1829 he requested a year's leave of absence from the Board so that he could comply with his doctor's recommendation to winter abroad. Someone had to look after the school for that year, and Allan recommended Lauder. The Board investigated Lauder's suitability during the summer recess, then re-assured that he was a satisfactory and competent person, permitted him to assume office in mid-November. He was only twenty-six, and it speaks volumes for the estimation in which Allan must have held Lauder's abilities, not only as an artist but also as a person able to communicate with and keep authority over the students, that he should have recommended him for sole charge of the national Drawing Academy.

Lauder's original intention, as revealed in his application to enter the Academy, had been to become a portrait painter, and in the second half of the 1820s he produced several sensitive and arresting portraits of members of his own family or of artist friends, which he almost certainly painted for no fees and exhibited to draw the attention of potential paying clients. The charm of these portraits is probably due to Lauder's intimacy with his sitters, and at his best he was capable of portraiture that was more penetrating and imaginative and of a finer quality altogether than that of Watson Gordon, who had become Scotland's chief portrait painter after the death of Raeburn. Watson Gordon, however, was an extra-ordinarily efficient portrait-producing machine whose results could be relied on always to reach the same adequate level. Lauder, one suspects, may have been erratic. The beautiful depiction of his younger brother Henry (catalogue no. 3) is an example of Lauder's portraiture at its finest. It is an exploratory and experimental work, revealing the painter's love of different surfaces – fur, bright metal, starched linen or the smooth luminosity of human skin – and a delight in the complexity of reflected lights thrown up into unexpected shadowed places – below the eyebrows, for instance – with an equal delight in paint as a substance that must change its texture or transparency in response to every variation in the substances portrayed. It is a type of portraiture at the furthest remove from that of Raeburn, whose paint was evenly opaque and whose art was a very sophisticated one of reduction, omission and simplification. In a Raeburn the distinctions between a curl of hair, an ear, a hat brim, a creased coat lapel or a metal button catching light on its edge, are erased, and all substances equalised into the same substance.

e) William Bell Scott. Life drawing copied from another drawing executed in 1827 before the Trustees' Academy possessed a life class.

Lauder's painting The Bride of Lammermoor

Lauder was also turning tentatively to subject painting, and in 1831 exhibited at the RSA a scene from *The Bride of Lammermoor* which in its confrontation between the dark and accusatory figure of Ravenswood and the wilting, satin-clad Lucy, reveals, more clearly than Lauder him-self can probably have realised, how strongly he was dominated by William Allan's imagery in the *John Knox admonishing Mary Queen of Scots* of 1822. *The Bride of Lammermoor* is an immature though interest-

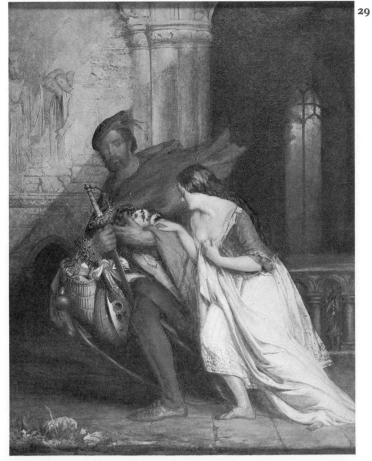

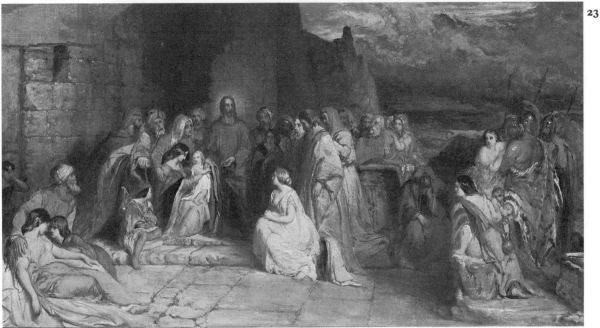

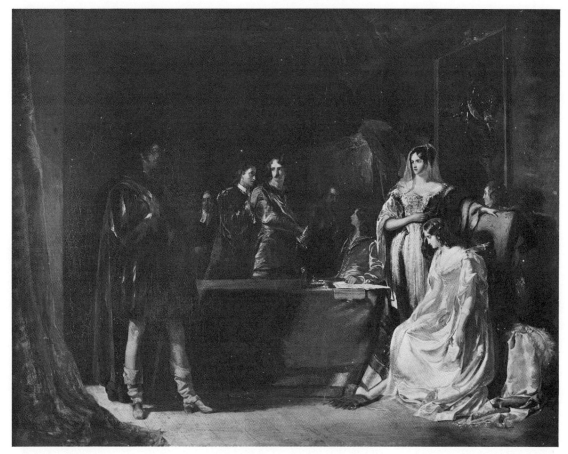

ing work, suffering from the unfortunate effects of bitumen in the shadows.

At some point Lauder had become acquainted with Thomson of Duddingston the amateur landscape painter, whose tastes, influence and advice were helpful to him. Thomson teased him about his dandified style of dress, but there may have been a reason for this, since in due course, in September 1833, Lauder married Thomson's daughter Isabella, herself an amateur artist. In November of 1833 the newly-wed couple set off for Italy on a visit that was to last five years.

f) Robert Scott Lauder. *The Bride of Lammermoor*, first version of 1831.

Marries and goes to Italy

2. Lauder in Italy and London

LAUDER'S ROMAN journal and account book commences abruptly and dramatically 'Arrived in Rome on the middle Nov 1833. £50 in my pocket and troubled with melancholy forbodings regarding my future'. Things started badly simply because Lauder knew no-one amongst the foreign community resident in Rome, and therefore could obtain none of the portrait commissions required for bread and butter. In due course, however, he did acquire a sitter, a Mrs Montgomery, and immediately began to worry, 'During the night I thought of nothing but the position to be adopted what kind of dress, what drapery, what kind of effect, for thought I if I fail in this, my damnation is certain.' The portrait was duly begun, but three days later Lauder suffered another crisis, and scraped it all out, 'I had mistaken the character of the Lady, what I had done would have been suitable enough for Lady Macbeth, certainly very

Lauder's Roman journal unsuitable to her.' The whole of his brief journal indeed is a reflection of his mercurial elations and depressions, and of his dreamy not very practical temperament. The family purse was several times quite empty. On one occasion he was temporarily relieved by a loan from his friend, the painter Lees. On another, the servant of his first patron Mr Montgomery arrived at an opportune moment.

'"Monsieur Lodare Monsieur Montgomeree mee bid gif diss" and pulling from under his cloak a monstrous bag of scudi he laid it on the table, Isabella had caught up a book pretending to read it turned out however that the book was upside down, in the meantime I had spoiled two or three pieces of paper in an attempt to write a receipt at last I managed one which I daresay would make Montgomery believe I had never learnt to write ... at last he was gone Isabella's book struck the roof, nearly in its progress demolishing a lamp and in another the glittering lucre was in her lap and she set to counting it in a very hysterical style.'

In a more sober, and less hysterical style Lauder corresponded with David Ramsay Hay the Edinburgh painter decorator, a personal friend not only of himself but also of David Roberts, who had been a fellow *Corresponds with D. R. Hay* apprentice with Hay. Lauder used Hay as the agent to handle and frame those of his own paintings and of his younger brother James Eckford – who had joined him in Rome – which were shipped back for exhibition at the RSA. Hay's own house was also a kind of home showroom for his friend's pictures, and it was there that Didbin visiting Scotland in 1836 saw and admired Lauder's *Peveril of the Peak*. Lauder's later portrait of David Roberts in eastern dress (catalogue no. 21) was bought by Hay, and whilst in Rome Lauder painted a self-portrait for Hay which he intended as a sample or advertisement of his abilities directed at what he called 'The Scotch market'.

'I am very anxious to make a respectable figure in your collection of Portraits, and as I said before think the wisest plan would be to take your own opinion and his (Thomson, his father in law), before it is criticised by anybody, for in case either you or he should consider it a failure, I shall be happy to paint another or half a dozen, that you may have one really worth possession and creditable to me.'

It is from Lauder's letters to Hay that we learn about his dislike of the painter Harvey (later PRSA) – 'his works always appeared to me to

come out of a mill that certainly worked steadily but the meal had always a twang that spoilt the parritch, however he has a kind of talent that will please the million' – and his affection and admiration for Thomas Duncan (later Master of the Trustees Academy) – 'he gives exquisite beauty with a mixture of the comic which is quite enchanting'. These are shrewd judgements.

It is also from the letters to Hay that we learn of Lauder's doubts and uncertainties about his career, 'The devil who is perfectly well acquainted with a strengthy weakness of mine which is a wish (to) possess a respectable name in my profession, has so managed that though (?) I work as hard as half a dozen it will avail me nothing, for he so scatters everything I do about the world, taking care that the worst is always where the best should be, then people say of the worst what is this all? and of the better, perhaps in the backwoods, but what does it mean?' As a prediction the self-analysis is ominous, and was to be uncannily fulfilled in Lauder's subsequent career.

Lauder's doubts about his career

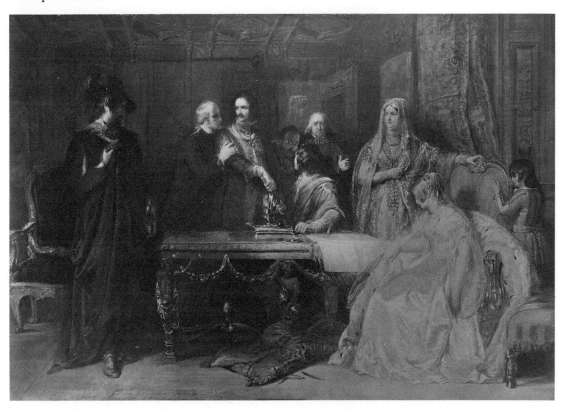

Besides his bread and butter portraits Lauder was tossing off some exquisite versions of the usual visitors' sketches of picturesque Italian peasants, and, more significantly, he completed a new version of his *Bride of Lammermoor* which can be seen in the background of catalogue no. 11 and which sums up, with the perfection of the scientist's controlled

g) Robert Scott Lauder. *The Bride of Lammermoor*, second version, painted in Italy.

experiment, exactly what he had learnt in Italy. To understand this fully
it is necessary to look back on Lauder's relationship with another Scottish
painter, David Wilkie. In a purely personal sense there had probably been
little contact between them as they were nearly always in different places
from each other. The direct influence of Wilkie's pictures on Lauder's
early work can also be discounted, because the paintings exhibited by
Wilkie in Edinburgh during the 1820s and 30s were rustic genre scenes
rather than the deeply shadowed historical subjects of the second half of
his career. Nevertheless Wilkie's RA exhibit of 1838 – the year of Lauder's
return to London from Italy with *The Bride of Lammermoor* number 2 –
was *The Bride at her toilet*, a work which shows that both artists had,
though by apparently independent routes, assimilated very much the
same lessons offered by Italian painting – especially that of Leonardo and
the Venetians, and their artistic heirs in the low countries, Rubens and
Rembrandt. The explanation need not be looked for in simple coincid-
ence, or in any zeitgeist operating on the temperamental affinities of all
Scottish artists in Italy – Dyce, after all, absorbed very different lessons
from his visits – but rather in the agency of William Allan as friend of both
Wilkie and Lauder.

Influence of David Wilkie

h) David Wilkie. Unfinished
picture of *Knox dispensing the
Sacrament at Calder House*.

Allan and Wilkie had been taught by Graham at the Trustees'
Academy the pictorial principle of contrasting warm tones (red, brown
or orange) with cool ones (blue, blue-green or purple). In Graham's
system the shadows, which ought to be thin and transparent, should also
be warm (brown), the middle tones cool, and the highlights again warm
(creamy or yellowish white), and fairly thick. Wilkie's oil sketch for
John Knox preaching was carried out under the influence of Rubens'
allegorical *Marie de Medici* series of paintings, which confirmed his
belief that the system of warm shadows and highlights was correct, and
should be adhered to if a rich, glowing and deep effect was to be attained.

LAUDER IN ITALY AND LONDON

When Wilkie brought this sketch to Edinburgh in 1822 it is not likely that Lauder, a student of barely two months, was privileged to see it. Allan, on the other hand, certainly did, for he immediately embarked on a series of historical paintings featuring Knox, or Mary, or both, which show its direct influence. The first of these, *Knox admonishing Mary* was finished and shown at the RA less than a year later. This is the picture already mentioned as the chief influence on Lauder's first *Bride of Lammermoor*. The direction in which Wilkie was travelling was further confirmed in his own mind as the right one when he visited Italy and encountered the chiaroscuro of Leonardo and (uncleaned) Titian. His mania, already transmitted to Allan, for brown shadows, was propagated by the latter so effectively that it soon became the hallmark of Scottish painting. 'The method peculiar to the Scotch school of painters is considered in London to involve an inordinate use of glazing. If a picture makes its appearance in which the effect is produced by relays of thin transparent colour, with shadows of asphaltum, it is at once put down as a Scottish picture . . . any picture painted without much depth, is certain in Edinburgh to meet with condemnation.' Thus William Bell Scott in 1850. Lauder, having followed Wilkie so far, was predisposed to take the same course in Italy, and examine especially the Venetians. Though a weaker draughtsman than Wilkie, he was a finer and more robust colourist, and his study of Venetian art encouraged him towards the splendours of saffron, orange, crimson and green, and coloured glazes, rather than the magic harmonising properties of brown. The influence of the Venetians on the colouring of the second *Bride of Lammermoor* is as apparent as the influence of Leonardo's *Last Supper* on its shadow structure and figure grouping. Both Wilkie and Lauder, in choosing to following the rich and shadowed painters of the sixteenth and seventeenth centuries, had turned their backs upon the newly rediscovered attractions of fifteenth-century Florentine frescoes with their hard outlines and pale bright colour. But while Lauder painted *The Bride of Lammermoor*, his fellow countryman Dyce was painting *Francesca da Rimini*. Dyce's subsequent success and Lauder's failure in obtaining commissions to decorate the Houses of Parliament are prefigured in these two pictures based on contrasting historical styles.

In May of 1838 Lauder, together with his wife and two children, left Rome for England. He travelled slowly through the summer by the overland route, stopping, as his passport stamps reveal, at Florence, Bologna, Venice, Munich and Cologne. Once in London he settled down at 35 Upper Charlotte Street, Fitzroy Square, the house that John Constable had occupied until his death. Lauder had been earning a satisfactory but not lavish income painting portraits in Rome – his average yearly income in Rome and for the first years of his second London period was £353.8.6d – and he had every reason to suppose that he could establish himself successfully in London. The thought of returning to Edinburgh probably never entered his head. After all, as David Roberts said, 'London . . . is the standard for testing the true metal (i.e. of the artist)'.

For an artist to achieve good professional standing in London during the 1840s it was essential that he should exhibit at, and ultimately become

Influence of Venetian art on Lauder

i) William Dyce. *Francesca da Rimini.*

Settles in London

a member of, the Royal Academy. From the record of Lauder's exhibits it is clear that he was putting his mind to work with concentration upon the establishment of his reputation. His new pictures all went first to the RA – which would not accept previously exhibited works – and they were then dispatched to the British Institution or the Royal Scottish Academy, a pattern that continued without a break until 1848. His subjects con-

Lauder's historical pictures tinued to be drawn from the novels of Walter Scott. William Bell Scott rather sarcastically pointed out that there were two schools of aspiring history painters in London at this period; the Englishmen Dadd, O'Neil, Frith and Egg who habitually illustrated *Gil Blas*, *Don Quixote*, and *The Vicar of Wakefield*, and the Scotchmen, Lauder, McInnes and Alexander Johnstone who illustrated *The Gentle Shepherd* and the *Waverley Novels* with equal perseverence. 'It is impossible to say that this society was exhilerating or even amusing.' Scott, on the other hand, did claim that Lauder was in the van of a movement to depict period costume and architecture more correctly than had been done earlier in the century. However, the novelist Thackeray who reviewed Lauder's *Claverhouse and Morton* of 1844 was scathing in his denunciation of the totally in-accurate costumes, and a quick survey of Lauder's subject pictures of the 1840s does tend to support Thackeray's rather than Scott's judgement in the matter. The trouble is that the artists of the 1850s and 1860s developed such an improved grasp of authentic period detail that their pictures tended to make the works of the 1840s appear in retrospect somewhat factitious and flimsy. These costume deficiencies – if such they are – were of course not nearly so apparent at the time, and David Roberts, whose own outstandingly successful career should, one would think, have certified his acumen as a judge of public taste, believed that it was by Lauder's historical subjects that his reputation would live, and that he really ought not to bother so much about portraits. Roberts felt particu-larly vehement over the portrait of Professor Wilson/Christopher North (catalogue no. 22). 'Lauder has now found out that however profitable portraits may be fame to the artist is preferable and that however the self-dubbed connoisseurs of the Modern Athens may be lost in wonder – at the superior excellence shown in the painting of flowing locks, of "The Professor" as they call him, it is not likely to raise him in the estimation of his brother professors here – or pave his way to the distinction of RA.' – a judgement that appears a little surprising now, but Roberts disliked Wilson and this may have affected his attitude to the picture. In a rather touching plea to D.O.Hill, with whom Lauder corresponded inter-mittently, he mentions the Claverhouse and Morton picture and begs for suggestions on suitable subjects 'as I have more trouble in selecting than in painting'. The choice of Scott may thus have been mainly habit.

The period between Lauder's return to London in 1838 and the mid-1850s was the most fertile of his career. To the series of portraits of

Portrait of David Roberts Scottish artists, begun in the 1820s, were added the portrait of Roberts in Eastern dress (catalogue no. 21), and the portraits of David Scott and Thomas Duncan (catalogue nos. 19 and 20). The Roberts portrait is the richest and most flamboyant in colour and setting Lauder ever painted, and one can feel how he revelled in the striped folds and fringe of the sash,

the crimson, gold, and emerald, and the polished hilt of the sword, but this obvious glamour should not blind one to the quieter merits of the small Scott and Duncan pictures. Perhaps just because no attempt was made to render them publicly impressive, they are deeper, more forcible, and more personal presentations of unique individuals.

The series of illustrations to Scott, begun with *The Bride of Lammermoor* culminated in the two *Quentin Durward* pictures of 1851 (catalogue nos. 27 and 28) and the *Gow Chrom* from *The Fair Maid of Perth* (catalogue no. 29). These show Lauder's subject painting at its best, and together with his *Burns and Captain Grose* (The Dick Institute, Kilmarnock), became a strong influence on Scottish painting of the 1850s, especially on the work of Fettes Douglas.

Lauder's taste in contemporary British art is interesting. He was impressed and moved in 1841 by Eastlake's *Christ weeping over Jerusalem*, a fact that has a bearing on his own later religious subjects, and he was completely won by the grace and beauty of Maclise's *Sleeping Beauty*, though critical of its colour, light and shade – at no time was beauty of form enough for Lauder without beauty of colour as well!

During the 1840s Lauder's own paintings were habitually accepted and hung at the RA and on the whole he received excellent notices in the press, but actual membership of the Academy still eluded him. His name stood on the list of about 60 candidates for Associateship from 1845–7. In 1845 he received one vote and again in 1847 one only. By 1848 his name had been withdrawn (presumably by himself) from the list, and after 1848 he never sent another picture into any Academy exhibition. His younger brother James Eckford, shadow-like followed his example. David Roberts, who was extremely concerned about Lauder's severence of relations with the Academy, wrote in 1849 'he seems soured – and seems to look more to another place this is to be regreted (sic)'. In 1849 Lauder was not the only artist looking to 'another place' than the RA. Throughout the decade there had been mounting criticism of this establishment, centred especially on its exclusiveness. Whatever the genuine faults of the RA may have been, the fact is there were by the mid-century more professional – and unprofessional – artists than ever before. The exhibitions had swelled in size. The paintings were jammed frame to frame, but even so a vast number of rejects was inevitable. The disaster for the rejected artists lay in the lack of alternative outlets. Politically, the end of the decade was characterised by international anarchy and revolt. In England the dissatisfied artists had recourse to their own anarchic substitute for the Academy.

'To the butcher and to Lawder to enquire about the free Exhin, could not see him . . .' so wrote Ford Madox Brown in 1848 (Virginia Surtees, *The diary of Ford Madox Brown* Newhaven and London 1981). This 'free' exhibition, which transmigrated through many exhibition venues and as many different names – The Free Exhibition, The Portland Gallery, The Hyde Park Gallery, The National Institution – was really free in the beginning, without government or rules – 'The boudoir of the martyrs of the profession' the *Art Union* scoffingly called it, and it very nearly foundered. When it had been rescued and properly organised,

Lauder's relations with the Royal Academy

(23)

Lauder, who had been involved from the start in 1847, emerged as its president. His name and excellent reputation must have gone far to give it respectability in the eyes of the press, and by 1850 when the free exhibition had obtained new custom-built premises and become The National Institution, *The Art Journal* (formerly the *Art Union*), changed its tone. 'The establishment of a free exhibition is a project worthy of an advanced intelligence' it declared. Lauder's defection from the RA stemmed from reasoning like Milton's Satan – 'Better to reign in Hell than serve in Heaven' – and David Roberts thought it a disastrous mistake in strategy. He believed that if Lauder had persisted, official recognition and membership would surely have followed. It is hard now to be so confident of this. To succeed in London the Scottish artist had to be not merely as good as, but probably markedly better than his English counterpart, with the stamp of something unique and novel in his work. Wilkie and Roberts himself are examples. At the beginning of 1848 there were only five RA's who were Scots. Previously the only Scottish RA's had been Raeburn, Wilkie and Geddes. The Academy, however, contained many painters who were arguably lesser artists than Lauder. Their friends had voted them in. Wrongly or rightly, however, Lauder had burnt his boats. There could be no prodigal's return to the RA.

j) Joseph Noel Paton. *The
reconciliation of Oberon and Titania*,
exhibited at Westminster Hall
in 1847.

Looking back, the 1840s seems to represent something of a lull or calm, during which figurative painters like Lauder were content to manipulate the inventions of Wilkie without changing them very much, but Pre-Raphaelitism arrived in the next decade, to turn the accepted notions of representation topsy-turvy. In one way though the forties were remarkable, for the surge of interest in large-scale mural art with ennobling historical or religious themes, a movement centred on the fresco decoration of the rebuilt Houses of Parliament. Since the artists to decorate Parliament were selected in open competitions, membership of the RA was irrelevant – indeed the Academicians in the main chose not to participate. The competition of 1847, in which fresco was not required, offered Lauder another chance and he seems to have put everything he

possessed into his two entries, *Christ walketh on sea*, and *Christ teacheth humility* (catalogue no. 24). Two years' preparation had been allowed by Her Majesty's Commissioners, and *Christ teacheth humility* was the supreme effort of Lauder's career. It was not successful. When the exhibition of the contestants' works opened in Westminster Hall, Lauder's paintings had obtained no premiums. A premium was won by Noel Paton for his *Reconciliation of Oberon and Titania*, and ironically another by James Eckford Lauder, whose *Parable of Forgiveness* (now in the Walker Art Gallery, Liverpool) was a more conventional reflection of his elder brother's work. Many of the exhibition reviewers were startled by the younger brother's success and thought it should have been the other way round. It was perhaps a slight comfort that William Allan's *Waterloo* had likewise been passed over. Roberts was indignant about the neglect of Lauder's work at Westminster Hall 'where it was . . . quite overpowered by the colourful – and in most cases coarsely painted Painted (sic) works by which they were surrounded – I by no means write this in the literal sense – the conception as well as treatment was coarse – or vulgar perhaps would be more correct . . . this may be Painting on a great scale – but it is not High Art – Both Sir William and Lauder made a mistake in sending there at all.'

There are faults of draughtsmanship in Lauder's picture, the natural outcome of working on an unprecedentedly colossal scale. These, however, were common for the period and were probably not the true reasons for his lack of official success. Explanation must be looked for at a more fundamental level.

k) Alexander Christie and students of the Trustees' Academy. *Four Saints*, exhibited at Westminster Hall in 1847.

Wilkie, towards the end of his life, had shown an increasing interest in religious painting, his last unfinished British picture being the *Knox dispensing the Sacrament at Calder House* (now National Gallery of Scotland) which was based on Leonardo and Rembrandt. He died in 1841, on his return journey from Palestine, after collecting material for a new and more authentic oriental portrayal of Jesus' life. Lauder, it may be, felt that the mantle of responsibility for a new religious painting had now fallen on his shoulders. He, of course, had not visited Jerusalem, but the oriental costumes, and massive stone courses of Jerusalem's curtain wall in his painting, indicate that he had probably turned to David Roberts for information and assistance in details of authentic costume and architecture. Though far larger, Lauder's picture is firmly in the tradition of Wilkie's *Knox*, highly painterly and complex in technique with transparent shadows and extensive use of glazing. Lauder's compositional source may have been the Rembrandt etching of *Christ healing the sick*, a print of which he owned. His stylistic sources were as already mentioned, Wilkie, and then an amalgam of the Venetians and Rubens. The small oil sketch (catalogue no. 23) is even richer and more vivid, with touches of orange and vermilion placed rather for their value as glowing colour notes than for any naturalistic reasons. This immediately reveals what may have seemed wrong with Lauder's picture in the eyes of Her Majesty's Commissioners, for the preferred style of the day for historical art was one based on the revivalist 15th century frescoes of the Nazarenes and their German followers and successors. This, with certain

Influences on Lauder's Christ teacheth humility

(25)

modifications, was the style followed by Dyce, who was one of the artists most deeply involved in the decoration of the Houses of Parliament. Fresco is a linear opaque medium, and revivalist works were heavily stylised. The naturalism, painterly glazes and chiaroscuro of Rubens, Rembrandt and the Venetians as followed by Wilkie and then Lauder, were thus as wrong in technique as decadent in historical antecedents, a tradition running exactly counter to the English artistic trends of the 1840s. Noel Paton, who did win a premium, was far more in touch with these current trends than Lauder. The incompatible nature of Paton's and Lauder's ideas about art was to emerge forcibly ten years later in connection with the teaching methods of the Trustees' Academy.

R.A.P.F.A. *buys*
Christ teacheth humility Happily in 1848 the Royal (as it later became) Association for the Promotion of the Fine Arts in Scotland bought Lauder's *Christ teacheth humility* wishing to 'shew the high estimation in which they hold great efforts in the Noblest department of Art'. After the usual draw it went to its new owner, Mr Chadwick of Salford. In January the Association received its Royal Charter of Incorporation, in which it was stated that the sums of money raised by subscription and contribution should be devoted not only to the purchase and distribution of works of art amongst the RAPFA members, but also to the formation of a Public Gallery or Galleries of Art in Scotland. With the idea of gradually forming 'a National Gallery of Modern Art', the Committee of RAPFA approached Mr Chadwick, and offered him £200 to buy back Lauder's *Christ teacheth humility* as the foundation picture of the proposed National Gallery. Chadwick very generously agreed to let RAPFA have his picture – at half its previous value! – and the Committee cannily reminded subscribers that since the original asking price of Lauder himself had been £1,000 they had certainly obtained a bargain for their £200. In a euphoric speech at the AGM held in July 1849 Sheriff Gordon announced the re-purchase. 'The Royal Charter which incorporates your Association requires a certain percentage of the subscriptions each year to be set aside for the purpose of purchasing Works of Art to form a National Gallery in Scotland. Ladies and Gentlemen, the first picture of that National Gallery is now before you . . . that noble picture of Robert Scott Lauder of "Christ teaching humility", begins our gallery – a masterpiece worthy of the artist's brilliant reputation, worthy of his countrymen, and of his country – (loud applause) . . . I see in the far vista of time that great painting encircled year after year by the worthiest productions of Scottish genius in every department of the Fine Arts.'

The installation of Lauder's painting in Edinburgh thus preceded his own removal there, and its technique created great interest on the part of one young artist, Alexander Bell Middleton, later to become a pupil. 'A great part of the flesh, particularly of the females, has been painted with cool pearly greys, and then scumbled and glazed with warm colours,' he reported, 'there is much glazing in the draperies – at least I imagine *Lauder's colour technique
arouses interest in Edinburgh* so. The figures with pale emaciated faces are clothed in greys of different hues; while those with highly coloured countenances are clothed in Reds or other vivid colours.' There was one form of popular accolade, peculiar to the nineteenth century, that might be awarded works of religious art

that attained the requisite breadth of appeal, and this was immediately awarded to Lauder's picture. In 1848 D. O. Hill wrote to tell him that he had by chance attended a service in the secessionist church of Fala – a remote country village – where the painting of *Christ teacheth humility* formed the subject of the sermon!

This, no doubt, was balm to Lauder's wounded feelings, and with the burden of his double failures in the London art world the formal offer of the Directorship of the Trustees' Academy in Edinburgh must have come to him in 1852 as the godsend of an honourable retreat. He was 49 years old by now and was in very serious financial difficulties, so that the salary of £200 must have seemed like a godsend as well. Roberts thought it a bad decision 'I do not like the idea of his leaving London and will miss him much but he for some years past had estranged himself from the Academy and became the leader of another body of artists, which I rather think he has found out now to be a mistake and probably this may have had very considerable influence on his withdrawal from London.'

WHEN THE BOARD made its offer to Lauder there was already an active Director of the Trustees' Academy, Alexander Christie, with whom Lauder was expected to rule in partnership as co-director. To find out the reasons for this extraordinary Board decision, it is necessary to go back some years and retrace the history of the school during Lauder's absence.

In 1837 The Board had appointed two new masters, William Dyce and Charles Heath Wilson – son of Andrew Wilson – to start a new department solely for the teaching of design for manufactures. In the event Dyce went abroad and never opened his class. Only two students had volunteered to transfer from Allan's section, but the Board, undaunted by this, simply press-ganged a sufficient number and left Wilson to deal with the angry and recalcitrant crowd as best he could. By 1850, therefore, the school consisted of two departments, one for the elementary and applied design students, the other for fine artists.

The hours of the classes were from eight to ten o'clock in the morning, and from six to eight o'clock in the evening on weekdays. This rather surprising timetable was conditioned by the working hours of the design students, many of them apprentices in full daytime employment. In the winter these hours must have meant that most of the time the students were working under artificial light. Things were organised so that in the life classes the male models always posed at the evening class, the female at the morning – presumably to ensure that the women did not have to return home after dark.

The staff was as follows. Alexander Christie was Director at a salary of £200. John Ballantyne, described as Head Master, ran the colour and advanced classes at a salary of £175. Then there were William Crawford, first Preceptor, his assistant, at a salary of £150 and Mr Dallas, second Preceptor, Christie's assistant, also at a salary of £150. There were additionally, Professor James Miller who lectured on anatomy, clerical

3. Lauder's Directorship of the Trustees' Academy

The Trustees start a Design Department

Staff and facilities at the Trustees' Academy prior to Lauder's appointment

staff, a porter and curators (i.e. warding staff) for the Picture and Statue galleries. The library was being augmented by books such as Billings' Geometrical Treatises and periodicals such as *The Art Journal*, the picture collection by works as diverse as Bonifazio's *Last Supper* and drawings by William Allan. The 'Statue', or cast collection, which had been catalogued by Charles Heath Wilson in 1837, was now supposed to represent 'the history of sculpture during a period of rather more than two thousand two hundred years.' The earliest items were the pediment and metope sculptures of the Parthenon, the most recent, figures by Canova and Thorwaldsen. The majority of the pieces were classical. Medieval art was represented only marginally by Ghiberti's Baptistry doors and Donatello's *St George*, Renaissance only by Michelangelo's *Dead Christ* (without the Virgin who had not been cast) and *Adonis* (this piece cannot be identified). Gothic, baroque, roccoco, and French and German sculpture were not represented at all. The time span covered by the collection was indeed long, but as a history it was select rather than comprehensive. The public were admitted with the injunction that they were 'earnestly requested' not to touch the casts.

The curriculum prior to Lauder's appointment

The categories for which prizes were awarded give some idea of the nature of the course, which now lasted three years. The elementary student began, as before, with 'Outlines from the Flat', proceeding to 'Outlines from the Round', 'Shaded drawings', 'Outlines from Raphael', 'Original designs', 'Perspective', 'Drawing from Antique', 'Drawing from Life Model', culminating at last in 'Painting from Life'. Sculpture was also taught, and the design students learnt the techniques of oil, watercolour, distemper, fresco and encaustic, while the fine artists of the Antique and Life classes learnt the principles of drawing, colouring, modelling, composition and design. 'The beauties and imperfections of celebrated works of Art, and the particular excellencies and defects of great Masters' were pointed out, and the Director was required to deliver an annual lecture course on the history of art.

The impression given in the draft report for the year 1850–51 is of a thriving institution steadily increasing in size and scope. The students are described as regular and punctual, persevering, diligent and determined, 'manifesting the greatest anxiety for improvement' and the number of competition drawings was so much greater than ever before that the usual exhibition rooms were not large enough to contain them.

Watson Gordon complains of deteriorated standards at the Trustees' Academy

The whole document is in truth a masterly piece of cover-up. Sir John Watson Gordon, the new President of the RSA, had been asked to deliver the prizes to the students, and it may have been at this moment that he observed disquieting symptoms in the standard of work indicating that things were not as rosy as officially reported. In May he went privately to Mr Maconochie, one of the Trustees, and told him that the Academy was in a deplorable state of deterioration.

The Director Christie was a very third-rate painter, appointed by the Board particularly for his ability to teach design. The Trustees, who were aware of his deficiencies as an artist, had got round the problem as they believed, by confining the Director to the task of teaching the design and elementary students, and by putting the advanced painting students

into the hands of Ballantyne, Christie's second in command. Such an injudicious arrangement was to terminate in almost predictable disaster. Ballantyne, who was not in fact a much better artist than Christie, has recently attained a rather quaint celebrity for his portrait series of famous nineteenth-century artists in their studios. Christie's own work can be seen in the NGS collection's *Incident in the Great Plague*, and a specimen of his teaching is the enormous revivalist altarpiece *Four Saints* (also NGS collection), which was designed by Christie, executed by two of his students, and entered in 1847 for the same competition as Lauder's *Christ teacheth humility*. It did not win a premium.

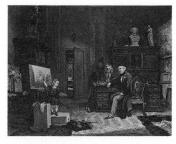

l) John Ballantyne. Portrait of David Roberts in his Studio (by courtesy of the Fine Art Society).

At the time that Watson Gordon made his complaint about the Trustees' Academy to Maconochie, the artists of the RSA and the members of the Board were enjoying fairly cordial relations after many years of strain and acrimony that had culminated in 1844–45 with a horrifying public row. The degree of provocation on the one side or of paranoia on the other is indicated by the RSA's firm belief that it was with the sole object of sabotaging the RSA attempts to start an art school of its own that the Board was prompted to add classes for painting and for the study of the living model to its curriculum. These additions, claimed the RSA, were 'each identical in its objects with the schools expressly contemplated in the minute of June, 1835, to be conducted by the Academy' (i.e. the RSA). The Trustees should properly be concerned, said the RSA, only with 'the improvement of manufactures and the departments of art connected therewith' not with 'instruction in the higher walks of art'. It is unlikely that the Board was pleased to be told by a body of artists which it had trained that its ancient school might 'still continue to afford very suitable instruction in the rudiments of art'. This bone of contention between two dogs, fine art training in Scotland, went with its accompaniments of money, cast and picture collections, books, and custom-built rooms, and so long as the Trustees had these and the RSA did not, the RSA was forced to suspend any plans for an art school of its own as set out in its Royal Charter of 1838. By 1851 these disgraceful quarrels had to all appearances been laid aside and the RSA possessed its own artist representatives on the Board, and thus had a voice in the management of the schools. Appearances were deceptive. Not for a moment had the RSA relinquished its plan to gain control of fine art education and manoeuvre the Trustees' Academy back into its first, applied design, role. Meanwhile, Watson Gordon set about introducing a suitable new director into the Academy.

Quarrels between the R.S.A. *and the Board of Trustees*

Watson Gordon's plan

Maconochie, whom he approached, was especially interested in design. Watson Gordon told him that the elementary and design classes were all right. It was with the classes for antique and colour that the trouble lay. There had been, he claimed, a distinct falling off in the quality of the drawings, and a quite alarming reduction in the number of students, which in William Allan's day had always exceeded fifty, but which had now dropped to between seven and ten. He suggested that Ballantyne was incompetent and should be sacked. The President's ally was well chosen and his strategy was successful. He was appointed convener of a committee to investigate the problem of the deterioration, and suggest a

*Investigation of the teaching at
the Trustees' Academy*

solution. When Ballantyne was challenged about the drop in attendance at his classes he accused Christie, the Director, of systematically withholding students who should have advanced out of the elementary class. Christie counter-accused with the charge that he had long suspected Ballantyne and Crawford of inefficiency. Ballantyne and Crawford effectively rebutted the charge with a dossier of enthusiastic testimonials from artists and students commending their aptitude, conscientiousness and care. At this point the committee realised it was getting nowhere. What was to be done? Gently the Convener was shepherding his flock along the path he wished them to take. At the beginning he had proposed that when Ballantyne had been sacked a 'highly distinguished artist' whom he had in mind should be appointed instead, but at a higher level. He had succeeded in making the committee aware that the present power structure in the school was unworkable. Now, apparently spontaneously, the various committee members began to declare that a new Director should be appointed, and that he should be a painter of 'the highest artistic attainments'. This agreement was only reached in December, but two months previously D. O. Hill and Noel Paton had been freely discussing the chances of Lauder's accepting the post – a non-existent post that the Board had not yet offered him, and the creation of which the committee had not yet even recommended to the Board! D. O. Hill was a member of the committee. Paton was not, and this makes it perfectly clear that the Trustees were being manipulated for the purposes of carrying out a pre-conceived RSA plan.

*Offer of the Directorship
of the Trustees' Academy*

After all the details had been settled, the chosen victim for dismissal was Crawford instead of Ballantyne. He protested of course, but money had to be saved somewhere, and since he was the most expendable member of staff no-one, except Maconochie, took any notice of his protests. A Treasury letter arrived authorising the changes, and an official offer was posted to Lauder in London, who replied almost by return of post on 18 February 1852, accepting the appointment of Director and returning thanks.

The first improvements made by Lauder at the Academy were physical. 'After writing many letters and attending meetings of the Board of Trustees I am at last empowered to put the Antique Academy into perfect condition' he wrote to Roberts at the end of December. 'The statues had not been washed since I saw them twenty years ago. They

Lauder's improvements

were so black that it was impossible to distinguish soot from form. They are now most splendid and I now do not hesitate to say that it is the finest Gallery for purposes of study in Europe. The number of students have risen from two to fifty and I doubt not I will soon make them produce good fruit.' In June of the next year he wrote again in jubilant spirit about his classes, 'I taste very great pleasure in teaching the young Ideas in the Academy how to shoot. There are between fifty and sixty youths in it, and I have succeeded in filling them with enthusiasm for our glorious Art. They are very steady and diligent and I have frequently been complimented by the Board for the progress they are making, and the discipline of the schools. The instant the doors are opened there is a rush to get their names in the book and then quietly to work.'

Lauder was a strict disciplinarian. On one occasion he refused to re-admit a student who had been irregular in 'conduct and attendance' because of the harm this behaviour did to the other students and 'the general discipline and progress of the class'. In the summer of 1853 he suspended one of his life students, John Myles, 'for having pointed out and taken notice of one of the Female Models in the street'. The wretched youth was not permitted to resume his place in the class until he had written a 'humble apology' explaining 'That it had proceeded from no bad intention on his part, but from inadvertence merely and great thoughtlessness', had sent another apology for the model in question, and had been severely 'reprimanded by the chairman in presence of the other students of the Life Class'. If this seems excessive we should remember that outside the walls of the Academy was a vast and uncomprehending public only too ready to cry out against the least hints of disorder or immorality in the arrangements of the school. At the RA schools in London no unmarried student below the age of twenty was allowed to work from the female nude, and only a few years later, in 1860, Lord Haddo, backed up by Mr Spooner, and supported by a petition signed by the Rural Dean and clergy of Birmingham, made a strenuous attempt to prevent any establishment where the nude model posed, from being funded with grants of public money.

Lauder's combination of intensive disciplined work and personal enthusiasm was infectious and proved a great success with the students. 'I was very much pleased with your retrospective sketch' Chalmers wrote to McTaggart in 1860. 'I felt my nervous system quicken as you recounted some of the incidents which to my memory are but as yesterday – our enthusiastic talk, our quick march up to the academy, our earnest work, our purpose to take *the prizes* (which we did).' 'Now my lad *work work*' Chalmers had written in 1857, when both of them were still students of the Academy.

m) George Paul Chalmers. *Crossing the Brook* (Aberdeen Art Gallery). This was painted by the artist immediately before he left Montrose to join the Trustees' Academy, and illustrates the standard of the students' work at first entry.

Years later William T. Whitley, who was visiting Orchardson's studio, cross-questioned him about Lauder. 'Orchardson laughed, and said he was a good master because he never tried to teach them anything. He remembered well when Lauder came from London and paid his first visit to the life class to see the drawings. "Lauder looked at my work, and said 'Ye-es, Ye-es', and then went on to talk about the weather. And that was almost all of it. He just left us alone."' This statement should be taken with a pinch of salt, for Orchardson was then a mature student who had finished the course and taken all the prizes under Ballantyne, but had come back again to see what Lauder could offer. Naturally he was not treated as a novice. Even the novice, however, was treated with extraordinary latitude by Lauder in that era of prescribed methods and enforced systems, as Hugh Cameron found. 'Mr Lauder first gave him a head to draw. He asked if he was to do it in any particular manner or by any particular method. "Method?" said Mr Lauder with amused surprise, "why no. Get the thing done!" To be left at liberty was new to the pupil.'

Peter Graham had two particularly interesting points to make about Lauder's teaching. 'One thing, he said, that lives in my memory, was the

effective way in which he gave "heartening" to his students. He was constantly encouraging them, and urging them, even at an early stage in their career, to begin and work upon a picture of some kind'. This may sound commonplace, but it was in fact extraordinary. At the RA schools in London any student painting pictures whilst he was still in the drawing classes had to keep it a secret, and the chief criticism of the RA classes that Holman Hunt had to make was that in the rigour and length of the drawing course the end purpose – the ability to paint pictures – was forgotten to the extent that it was never acquired by many students.

n) Unknown artist, pupil of Lauder, *A group of casts from the antique* (catalogue no. 36).

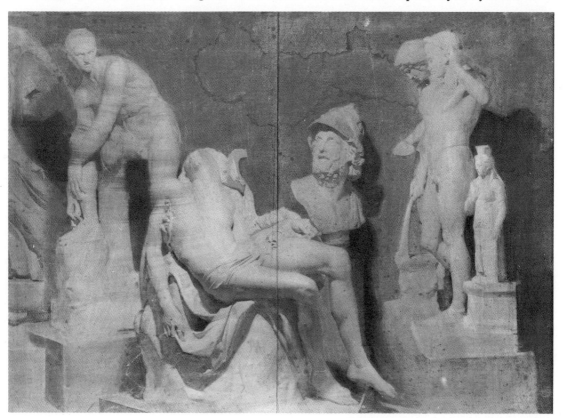

Lauder never lost sight of the pictorial understanding that the antique and life classes were intended to nurture in his pupils. As Graham said, 'Continued study from the antique and painting from the nude in a life class give, or ought to give, an acquaintance with light and shadow which to a landscape painter is invaluable. . . . In Edinburgh we had a long gallery with windows on the roof at intervals. . . . I shall never forget the exquisite beauty of the middle tint or overshadowing which the statues had that were placed between the windows; those which were immediately underneath them were of course in a blaze of light, and we had all gradations of light, middle tint, and shadow.' It is this experience as a student that informs Chalmers' later analysis of the tonal structure in one

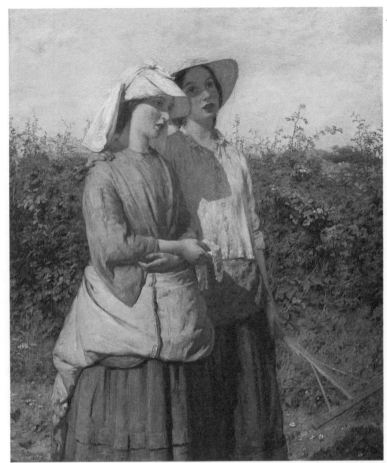

45 *detail*

53 *detail*

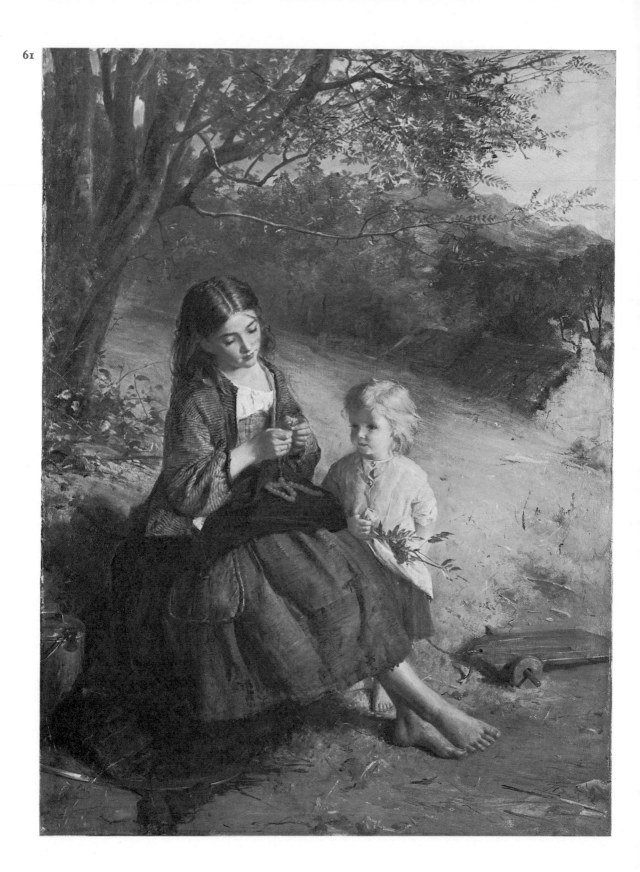

of his own pictures. 'Mark . . . how the light falls first on the *chair* – then *on the shoulder* and *down the arm* – then on the *head* (which is the strongest light) then travelling over the cheek – and hitting the hand smartly – then down to the knee – caught up by the smoke and going down the leg *in the half light* and lost in mystery about the feet – this will appear awful *tosh* no doubt – never mind – it has cost me a lot of bother to get this arrangement.'

In the background one seems to hear the echo of Lauder's voice teaching and gently encouraging this mode of observation. Lauder deliberately arranged his casts to produce these effects – after washing them to prevent the deposit of dirt from concealing the subtleties of their light and shade, his second action in 1852 had been to get them fitted with new castors so that they could be easily moved about and grouped.

Professor Stewart Traill who gave away the prizes in May 1854, in his speech described what was unique about Lauder's method of teaching. 'Among other excellences of his mode of teaching the study of the antique, I consider it of no small importance to the student that, while the utmost attention is paid to correct outline, the master teaches him to *group* the productions of ancient genius, so as to give to the representations of sculpture a fine pictorial effect. . . . Mr Lauder has been more partial to the Elgin Marbles than to most other ancient sculptures.' What Traill meant by this is very clearly illustrated in the antique drawings of Chalmers and McTaggart (catalogue nos. 37 and 38). Such exercises compelled the student to consider all the factors of physical and psychological relationship, space, and tone, that he would have to cope with when composing his own paintings, and it is not surprising that Lauder's students, even in their earliest and most immature pictures, should have evinced a particularly good grasp of composition and figure grouping. These gifts were especially marked in Pettie and Orchardson. As for the antique drawings themselves, I do not believe that anything resembling them was being produced by any other British art school at that date.

Originality of Lauder's method of teaching drawing from the Antique

Lauder's teaching could not produce its full effect instantly. In 1853, at the first prize-giving after his arrival, he recommended that ten prizes should be given for drawings from the antique, but none for life drawing or painting. The year after, however, the drawings in preparation were so good and so much larger than on the previous occasion that he asked for eight extra days for their completion, and made the further request that the judges this time should be members of the RSA instead of members of the Board. Professor Traill's tone, as he bestowed the prizes in 1854 was one of bubbling enthusiasm, 'It affords me the greatest pleasure to record the concurrent opinion of the Board and of The Royal Scottish Academy, and of all who have had an opportunity of judging as to the astonishing progress which is observable in the productions of the students.' A full report of the occasion and speeches was provided in the *Caledonian Mercury*, which Lauder posted to Roberts.

Student prizegivings

Lauder's official title was Director of the Antique. Obviously he supervised Ballantyne in the running of the painting classes, but without definite evidence it is hard to tell how far he himself was personally involved in these, and hence it is quite possible that the technique and

Lauder and colour

execution of such school works as McTaggart's life paintings may owe as much to Ballantyne as to Lauder. Certainly when proposals for a special course in colour were being discussed it was Ballantyne who was to run these classes. Nevertheless, though it may have been from Ballantyne that the students received their first lessons in the use of oil paint, Lauder's own paintings, together with the strong views he held about painting, would have prevailed in the long run. It was he who encouraged Orchardson to finish the picture of Wishart at St Andrews (catalogue no. 42) and we know from a letter to Roberts that he was urging his students to look at J.F.Lewis' copies of Italian old master – mainly Venetian – paintings (RSA collection), and the paintings by Etty (also belonging to the RSA). Etty was a kind of nineteenth century English Rubens, noted for his luscious colour, and these four major paintings, which had been bought by the RSA in 1829 and 1831, had probably been formative influences on Lauder's own early style.

The Trustees' Academy and the Royal Academy Schools, London, compared

If one compares Lauder's teaching and the Trustees' Academy system with what was available at the RA schools in London during the 1850s one finds that Edinburgh had one major advantage over the capital. At the Royal Academy the real teaching lay not in the hands of the Professors of Painting, Anatomy, and Perspective who delivered only six lectures a year each, but with the so-called 'Visitors', – nine artists elected annually, who attended the schools monthly in rotation to pose the model and instruct the students. As any student was continually seen by different Visitors there was naturally little chance of continuity and consistency in the programme of instruction. Some of the Visitors – at least in the earlier part of the century – took their duties very negligently. Landseer for instance spent his evening reading *Oliver Twist*. For the student at the RA schools it was probably a case of sink or swim, since it was no one person's responsibility to watch over and direct the growth of his talents from his first entry to the end of the marathon seven-year course. At Edinburgh the abilities and character of the Director were, for good or ill, the deciding factor in the benefit the Trustees' student obtained from his three years. This great discrepancy between the two schools in length of training might seem to favour London, but if Holman Hunt is to be believed, the years spent there on unprofitable specimen drawings were unduly prolonged.

Threat from the Department of Practical Art

In 1854 the Trustees were disturbed by rumours to the effect that the Board of Trade was proposing to establish a new School of Design in Edinburgh along the lines set out by the Department of Practical Art. D.O.Hill and Christie went south to investigate at the Schools of Design there. What they found out was both reassuring and faintly sinister. There was as yet no announced intention on the part of the Board of Trade to establish its own School in Edinburgh, but on the other hand, Cole and Redgrave, the two powerful superintendents of the London Schools, clearly believed that the design side of the Trustees' Academy was antiquated in its limited range of instruction and number of classes. To render the Academy a less vulnerable victim the Trustees immediately resolved on a number of modest reforms that would eliminate the most glaring differences between their school and the Government Schools.

(34)

The increase of classes, extension of teaching hours, and introduction of fees (the teaching in Edinburgh had always been free), may temporarily have averted, but did not in the long term prevent, the absorption of the ancient, small, and independent Trustees' Academy into the vast devouring cavernous maw of the so-called 'South Kensington' system of art teaching.

The crisis came in 1858 with the prospect of the opening of the new National Gallery next door to the old Royal Institution building on the Mound. At this moment the RSA remembered its longstanding, slumbering but never relinquished intention of obtaining the control over fine art training in Edinburgh, and on this occasion, for the first time, it had the sympathetic ear of the central government, and the Trustees had not. The Treasury announced in a Minute of 25 February 1858 that in the re-allocation of space and resources which would precede the move into the new building, the Trustees should run the National Gallery, that the elementary and design section of the Trustees' Academy should be affiliated with the Science and Art Department, but that the RSA should take over the Life School. There followed an exchange of passionate letters between the RSA and the Trustees, who were determined to prove that even after the expenditure of all necessary money on the running of the National Gallery, there would still be sufficient left over to continue running the Life School. Item by item the Academy refuted their claims, concluding with the *coup de grâce* that if the Board persisted in its stubborn opposition to the Minute, the RSA would feel compelled to notify the Treasury that each of the Board's students were being educated at an annual cost to the public purse five times greater than the government reckoned acceptable. 'Is it (the Trustees Academy) in such a state of efficiency? The answer is, it is not. In the midst of a population of 160,000 only 300 Pupils attend . . . great preponderance is given to one branch, and that the branch that falls least within their province viz that of the Fine Arts; and there the pupils are educated at enormous cost in the Antique School of £23.1.0 each pupil, and in the Life School at the sum of £30.16.0 each pupil.' It was enough, and the Board gave way.

Under the new system of affiliation the existing masters of the Trustees' Academy would retain their appointments, and their existing salaries, which would be augmented by the fees obtained from the students. Lauder on Monday, Wednesday, and Friday, was to take a male class from 8 to 10 am and another from 6 to 8 pm. On Tuesday and Thursday he was to take a ladies' class from 1 to 3 pm. His total working hours would thus be sixteen per week, which was two less than before. His new salary would come to £215. In hours and salary he was thus a gainer. On the debit side was the fact that he would be giving up his students to the RSA as soon as they had obtained medals in the Department of Science and Art stages 8 and 9. Stage 8 involved drawing the figure from 'the round' in outline, and elementary shading (whatever that was), studies of the human figure nude and draped, and sketching from memory. Stage 9 involved anatomical studies of humans and animals. The earlier stages had been concerned with linear and shaded drawings from objects and copies. The subsequent stages progressed to the painting

The Treasury Minute of 1858 on the partitioning of the Trustees' Academy

Affiliation of the Trustees' Academy with the Science and Art Department

of groups, compositions, and the human figure, and to colour composition. Clearly then, Lauder was going to lose his best students just at the point when the teaching of them would become more rewarding, and all the possible good effects of the more advanced students upon the elementary ones would also be lost. He himself would be relegated by implication to the status of an elementary teacher. A pencil addition to the Board *Report* on the new arrangements suggests that Lauder was sensitive on this point. 'It must be obvious that the Director of the Antique must in future give his whole attention to the Class of Antique – and have no connexion whatever with the Life Class of the Academy.' Two years later Lauder himself reported that 'The loss of the Life School had injured the Antique', and we know from a letter Pettie wrote to McTaggart that Lauder was unhappy about the way that the RSA were intending to handle the Life Class. 'He is wild at the new system which they (Drummond, Paton, Archer) are going to begin at the Life Class, open after the New Year. He feels that their rigorous drawing and inattention in the meantime to colour imply that his system has been all wrong.'

Lauder loses his 'life' class to the R.S.A.

The RSA were proposing to set up a school taught by Visitors similar to the RA schools in London, and the views of Messrs Drummond, Paton and Archer, are laid out in the *Report* they compiled at the RSA's request. Examination of this document shows that Lauder was not being hyper-sensitive in his reactions. Certain passages do appear to constitute an attack on his methods – though of course no names are mentioned – and the flavour of the whole is disagreeably priggish and Calvinistic. Whereas Lauder's emphasis had been on hard work motivated by enthusiastic commitment, the *Report* implies that the student must be mortified by a process rather akin to a spell of penitential labour. Rigour and severity are the keywords. Drawing was to be 'severe', 'correct', and 'learned', the training 'rigorous' and 'rigid' – 'The object of study from the Life' it is explained, 'being *not* to produce specious effects of colour and chiaroscuro (too frequently the sole object aimed at by so-called *students* of the Life), but *to comprehend the Organic Structure of man in its relation to Art*'. When at length, after very much severe drawing, the student was allowed to use some colour, care must be taken, 'not to divert his attention by grouping picturesque arrangements of background and the like'. The *Report* added 'It is, we trust, unnecessary to defend the rigorous course of drawing to which, previous to their being allowed to take up the pencil (i.e. paint brush) we propose to subject even the most advanced Students . . . and no one we think, can deny that the present tendencies of the Scottish School, as evinced by the works of many of the more promising of our younger artists, make it the imperative duty of . . . a Royal Academy of Art, to use the weight of its authority to enforce its adoption for the future.' – Poor Lauder!

R.S.A. *criticisms of Lauder's teaching. Drummond, Paton, and Archer's* Report

Drummond, Paton, and Archer were figure painters, born between 1816 and 1823. They thus belonged to a later generation than Lauder, born in 1803, and they shared (Archer to a lesser extent) certain artistic characteristics that belonged to their generation but were alien to Lauder – hard outline, highly worked detail, the effacement of brushmarks (giving the surface a look of machine-made precision), and the con-

ception of painting as the final application of colour to a correct and finished drawing. Viewing this clash of ideologies from the safe distance of over a hundred and twenty years one can see that Drummond, Paton and Archer were defending an even then rather outmoded theory, whereas Lauder was looking forward. Leaving aside the question of colour and whether it should be regarded as fundamental (Lauder) or merely a decorative addition to something else (Paton and Drummond), the issue in relation to the use of the antique was whether it should be revered as providing everlasting individual paradigms of 'types of beauty in Woman' and of 'strength and grace in Man' – the *Report*, but it might have been written in the eighteenth century! – or whether the individual pieces could be, as Lauder himself had used them, exploited as picturesque staffage in a gigantic still life, compelling the pupil to concentrate on abstract pictorial problems. Lauder's way of grouping the casts had nothing to do with historical periods, or national schools, they were on the contrary assembled together as strangely grouped encounters, Michelangelo's Dead Christ, a half draped Venus, a Diana robing and Laocoon struggling with the serpents – only welded together by the strong cast shadows into some semblance of dramatic and psychological unity.

The pity is that Lauder's attempt to synchronise the student's acquisition of the elements of painting so that he was always learning how to compose in tone and space, rather than merely how to draw an outline at one moment, or to represent a three dimensional form at another, repudiated as a method by the RSA, was also ignored in the vast and terrifying Government departmental system with its twenty-three stages. Christie died in 1860, and Lauder after 1861 ceased to teach. Under two conscientious nonentities, holding Government design school certificates, Mr Hodder and Miss Ashworth, the Trustees' School quietly withered into insignificance. A pupil wrote to the *Courant* in 1872 to complain, 'Fancy a student on two hours for three evenings a week during the best part of two sessions (ten months) working on one single figure drawing ... "The Department" will not allow us to draw a group, nor even select a figure – the head of Ajax, the figures of Germanicus, Discobolus, and Antinoux are the stereotypes ... willingly would the most of us return, were the teaching altered to what it was when Scott Lauder was the master.'

The Trustees' Academy under the Government departmental system

If Lauder's professional life had been a disappointment and his efforts towards art teaching cancelled, his private life had also been disturbed. At the height of his first resounding success in 1854 when the drawings of his students had created such a sensation at the public prizegiving, David Roberts came up to Edinburgh. 'Lauder seems altered' Roberts told his daughter, 'Not for the better / wears a long beard from the nose downwards, more absent and more stupid than I ever saw him – Either his affairs, or whiskey must have done this, or both / this is much to be lamented ... (he) seems most rabid against Royal Academy(s?) and Academicians ... Sir John (Watson Gordon) told me there is a vast improvement in the students since he took the management of the schools. This is likely – But as to his own improvement I fear this is now

hopeless!' Lauder was by then inextricably entangled in debts that seem to have been brought down on him by having stood surety for one of his brothers who failed. Roberts discussed with his son-in-law the feasibility of rescuing Lauder and whether 'if he ever be placed safely on his legs, he would be able to keep them – which indeed I greatly doubt.' In the event he did lend Lauder money, and the fact that this was never repaid eventually poisoned the previous friendship that had existed between them.

For Roberts, Lauder was at first 'a poor devil' but at length a 'false friend'. He was exasperated by what seemed like utter ingratitude, and also by Lauder's unwillingness to adopt a firm commercial approach to his difficulties and paint small pictures for Art Unions and the popular market. Lauder on his side may have found Roberts, for all his intended kindness, unbearably self-satisfied and smug. It must have been hard to submit to rescue and patronage (especially on 'the whiskey toddy part of the advice') from this successful Academician who had once been his equal. On the subject of commercialism too he was intransigent and would not lower his standards. 'Paint no more Crystall Pallaces' he had urged Roberts in 1852, 'or hospitals, things of either kind are unworthy of your powers. Remember, or rather never for a moment forget, that you have carried our hearts and souls to those holy fields over whose acres walked those blessed feet . . . Having done so great a deed modern trash is beneath your care.'

Besides his illustrations to Scott, and some landscapes, a regular part of Lauder's output was now in large religious paintings depicting the chief events of the Life of Christ. High Victorian religious painting is not now to everyone's taste, but Lauder did manage to introduce to each subject something of a fresh understanding. His *Crucifixion* of 1852 caused a good deal of astonishment because the figure of Christ was swathed in a white drapery. This now hangs in an Edinburgh church, so darkened by time that it is impossible to estimate its quality or interest. The 1853 *Christ Walking on the Water*, however (with the Fine Art Society in 1974) is a different matter. In this the figure of Christ is given a spectral unearthly quality that is extremely impressive.

In December of 1861 Lauder suffered a stroke. His mental abilities were not affected but he was no longer able to paint. Family tradition represents his hand as being paralysed. Five months went by and Lauder dictated a pathetic letter to the RSA, 'Gentlemen, – In December last I was afflicted with a Shock of Paralysis, which completely prostrated me, still my friends were not without hopes, that in the course of a few months I might in some measure be able to resume the exercise of my profession, but months have elapsed without much appearance of these expectations being realised.' He was still unable to paint and unable to teach. The RSA immediately placed him on its pension fund, and there was a further small pleasure in the fact that his bust by his pupil Hutchison was placed in the RSA collection. John Burr, William Quiller Orchardson, Alexander Burr, John Pettie and Thomas Graham wrote a letter of condolence to him from London in 1863. Their letter began; 'Dear Sir, – We have all met this evening for the purpose of addressing a few lines to your as a tribute

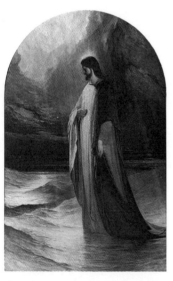

o) Robert Scott Lauder. *Christ Walking on the water* (private collection).

of the respect we feel towards you, our old master. We beg to express our deep gratitude for the great interest you took in your "boys'" welfare. Any success they may meet with will have an additional value in the pleasure which they feel assured it will give you.' Lauder lingered on without improvement until 1869, eventually dying only three weeks after his brother James Eckford.

The RSA Annual Report described how 'His love for Art, joined to a sensitive and ardent temperament, was fitted to kindle a corresponding enthusiasm in his students', and his students subscribed to raise a memorial to him over his grave in Warriston Cemetery. A high relief bust carved by Hutchison in fine marble was let into a plain slab of Sicilian marble inscribed with these words: Robert Scott Lauder RSA / Historical Painter / Born 25 June 1803 died 21st April 1869 / Erected by his students / Of the School of Design Edinburgh / In grateful remembrance / Of his unfailing sympathy as a friend / And able guidance as a master / 1870.

THE LONG TERM effect, not only of Lauder's teaching, and ideas, but also of his own painting, upon his students is extremely difficult to assess accurately, especially since they were of course exposed to many other influences as well. The presence in Edinburgh of paintings such as Wilkie's *Knox dispensing the Sacrament*, the two Van Dycks belonging to the NGS, the Gainsborough portrait of *Mrs Graham* and the occasional exhibition of Pre-Raphaelite pictures must be taken into account, along with the influence of living Scottish artists such as Harvey, Phillip, or Fettes Douglas, together with the powerful mutual influence upon each other normally found amongst a group of young friends living very much in each other's pockets.

It is clear, however, that Lauder predisposed them to take their work very seriously indeed, to adopt the very highest aesthetic standards for their narrative or genre pictures – an attitude that the damaging puritanical art criticism of the early part of this century has rendered almost incomprehensible until fairly recently – and to look for quality of paint and of colour, first and foremost. Those attitudes which Lauder's pupils shared and which were noted by critics as common and recognisable characteristics were part of the heritage they received from Lauder, and it is worth asking just what Lauder's pupils looked like to outsiders during the 1860s when they first came before the public eye.

'Iconoclast' in his *Scottish Art and Artists in 1860* wrote, 'Those of them who form what some call the New School stand much in need of caution and advice . . . Their pictures want finish, and are objectionable in colour; . . . Mr Cameron's principal picture . . . illustrates the leading vices of the school – slovenliness of work on the accessories and monotony of colour . . . Indeed, the love of grey and grey green exhibited by the school is ridiculous . . . Mr Orchardson's *Jeanie Deans* (catalogue no. 48) is especially grey and wretched.' McTaggart sometimes had difficulties even with his own patrons and admirers. 'Will you excuse me if I offer a

Epilogue. Lauder's students in Edinburgh and London

Various influences on Lauder's students

Criticisms of early paintings by Lauder's students

remark which I mean in all kindness – it has been very generally remarked that my 2 pictures are deficient in *finish* – and just too much like *sketches* – a feeling which has grown upon me the oftener I have seen them' wrote Robert Craig in 1860. In 1864 *The Daily Review* for 18 February, voiced a similar opinion of the bank in McTaggart's *Spring* (catalogue no. 53) '(it) looks as if it wanted nothing but a little working on to be perfect but it certainly does want that', and exactly the same criticisms met those artists who moved to London. For example take *The Illustrated London News* of 14 May 1864 on Pettie's *George Fox*, 'The first impression the present work conveys is not altogether pleasing, from the apparently sketchy handling, the somewhat scattered composition, the mass of rusty, faded tapestry lining the hall, and the too great prevalence of greyish browns,' and again in 1865 'Mr Pettie has, like Mr Orchardson, acquired a dexterity of handling which is a little too obtrusive.' The next year it was Orchardson's turn, 'Mr Orchardson's workmanship has considerable resemblance to that of Mr Pettie; but he is looser in handling, and has more canvas to let.'

In 1867 the same magazine was again busy with Orchardson, 'the composition is vacant, and we are sorry to see the painter's mannerism of conventional "scribbly" breadths of shadow more than ever apparent.' In 1870 *The Art Journal* took a similar line with four of Lauder's pupils. 'Mr Orchardson is another of our artists who relies almost too confidently on genius. "The Market Girl from the Lido" is clever and sketchy. Like objection may lie to an over-slight composition, "Adrift" by W. McTaggart . . . the idea is good, yet the picture, though of no ordinary ability, has been left little more than a "rubbing-in". Mr McTaggart dates from Scotland; and so once we imagine, did Mr T. Graham, judging from "The Wayfarers" . . . like to the Scotch school in general, and to Mr Orchardson in particular. The touch is ragged, the colour is broken, but the effect gained is powerful, especially at a distance.'

Too empty, too grey, too unfinished, ragged in touch and broken in colour – such was the consensus of opinion on the early works of the Scott Lauderites. Against what, one may ask, were they being measured? In Scotland it was perhaps the rather metallic colour and highly elaborated perfection of Paton or Drummond – every inch crammed with objects. In London the artistic field presented a more complicated pattern, with the Pre-Raphaelites and their followers, including the second generation Pre-Raphaelites such as Burne-Jones, the classical revivalists Leighton and Albert Moore, the still highly active 'old guard', Frith, Egg, Elmore, O'Neill, and Regrave, and some isolated individuals such as Landseer and Watts. Some of the main pictures painted or exhibited in 1865, the year of Pettie's *Drumhead Court Martial*, were Leighton's *Helen of Troy*, Whistler's *Little white girl*, Elmore's *On the brink*, Poynter's *Faithful unto death*, Rossetti's *The Blue Bower* and Burne Jones' *Green Summer*. Frith exhibited a mass official portrait of the Princess Royal's wedding. A strangely assorted company, but it suggests that in England the narrative or genre painters and the high aesthetes had somewhere parted company. On the one hand was overcrowded incident, trivialism and the moral bombast of the tract, on the other a purist retreat into a dream so remote

English painting in 1865

74

54

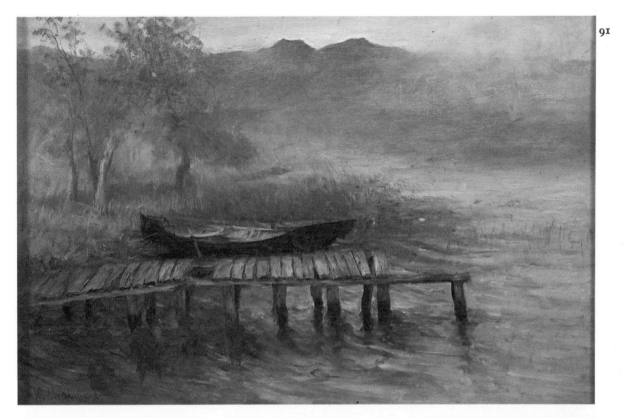

91

92

105 *detail*

that it hardly touched everyday life. Whistler excepted, both parties finished their work almost as highly as Paton and Drummond. Into this divided territory Pettie and Orchardson brought historical painting renewed by study of real human behaviour and psychology, not other-wordly or dreamlike but dramatic and concerned with action, and literary painting restored to the status of a work of art by being conceived primarily in terms of light and shade, shape, space, colour and brushwork. They were the last exponents of the Wilkie tradition. Even in their life-time influences from the Continent were reshaping figure composition along the lines of the close-up camera effect of Manet and Bastien Lepage. Against the interiors of Tissot, Frank Holl, or the Newlyn School, where the continental influence is paramount and the spectator jostles almost with the painted people, Orchardson's dramatic episodes distance and detach themselves from the spectator as if set beyond a proscenium arch, appearing by the 90s very faintly old fashioned.

Subject pictures of Pettie and Orchardson

One thing, not yet mentioned, Lauder did do for his students – he sent them out able to draw, so that those who went to London competed, as had never before been possible, on equal terms with the RA trained artists. Pettie, Graham, and Orchardson were frequently accused of sketchiness or lack of finish, but not of faulty draughtsmanship. Their success was extraordinary. Not only were the dealers queueing up ready to take pictures wet from the easel, but the official recognition of the London artists was to hand also. Pettie became an associate of the RA in 1866, Orchardson in 1868, Peter Graham in 1877, and MacWhirter in 1879. In 1873 Pettie became a full RA, so too did Orchardson in 1877, Peter Graham in 1881, and MacWhirter in 1893. The others, though not reaching membership, had their work regularly accepted, hung, and noticed at the RA exhibitions. Scotsmen of outstanding individual ability – for example Ramsay, and Wilkie – had indeed come South before, made their way, and scored individual successes, but it had never happened yet that a whole group of artists trained only in Scotland, and possessing a recognisable common approach, had moved into the top flights of the London art world, or established, as Lauder's pupils did, an identifiable character for the Scottish school of painting.

High standard of draughtsmanship of Lauder's students

One is bound to speculate on the effects that removal to London had on Lauder's pupils. Undoubtedly the move did widen their options with regard to subject matter. Orchardson's drawing room and ballroom scenes are exotics of a type that could only have flourished in a large metropolitan centre of wealth and fashion. They are inconceivable as a product of Edinburgh in the 70s and 80s, and had he stayed at home he might have continued to move to and fro between Walter Scott and a homely rusticity.

Effects of living in London on the work of Pettie, Orchardson, etc.

It is hard to tell how far the strongly linear element apparent in Pettie, Orchardson and John Burr was related to residence in London, for there is no linearity in Chalmers or McTaggart. Certainly it is safe to say that Pettie and Orchardson's strong use of line was related to their penchant for the psychological analysis of behaviour, the summary and witty presentation of a world of motives and reactions. One has to use one's mind on Pettie and Orchardson, and in no bad sense they are literary

painters. This cannot be said of Chalmers and McTaggart – both permanent residents in Scotland. Their pictures are devoid of intellectual or analytical content, and the faculties called into play by seeing their pictures are the feelings and emotions simply. Their subject matter is traditional genre and landscape, but in purely pictorial terms they were pioneers, going beyond the limits of previously explored, and into virgin territory, whereas Pettie, Orchardson, MacWhirter and Graham produced variants and refinements on what had already been discovered. The London which stimulated the intellectual aspects of Pettie and Orchardson may also in some way have limited their activities to known paths. The lack of a really strong academic tradition in Edinburgh may have had something to do with McTaggart's freedom to advance.

Returning to the technical points the early critics seized on – the ragged touches and divided colour – it is useful to listen to a more sympathetic commentator than the early journalistic critics. In 1901 McOmish Dott wrote of McTaggart, 'his technique has grown out of his Edinburgh apprenticeship . . . He was one of the glorious group of Scott-Lauderites. In technique this group followed the old tradition, "keep the shadows thin and transparent and the lights solid". Now as no transparent neutral grey pigment exists, this was practically translated into basing all shadows on transparent brown . . . This practice McTaggart has used in lessening degrees till it almost vanishes from his latest works: it, however, leaves on one the impression that his interpretation of transparent shadow is the least successful part of his technique. "Quality" of colour, . . . was also established as a distinctive trait by the Scott Lauderites, though not invented by them. Their mode of effecting wealth and luminousity in colour was by breaking the purer elements of a given tint separately against and through one another, instead of mixing them into a general tint on the palette before applying it – a sort of hatching or interlacing. This process, followed rigidly by Orchardson, and, qua colour, with beautiful results, is certainly against attaining breadth of handling.' The truth of Dott's remarks can be tested against the actual works of art. The colour hatching is as he says, particularly obvious in Orchardson, but it is also frequently apparent in Pettie, McTaggart and Chalmers. Only the day before his fatal accident Chalmers stood in front of Turner's *Lucerne* – almost certainly the water colour bought at the Munro of Novar sale by Chalmers' friend Irvine Smith, and now in the British Museum – and analysed the colour effects. 'Look at Turner's greys, at the distance of a yard the sky and water look simply grey, but go closer and see how that effect is produced. It is by blending in the most mysterious way the lights and shadows, and working into them touches of colour from the neighbouring masses, that influence the scheme of colour. You cannot tell why he added these touches, but you feel that without them the effect would be poverty stricken.' These remarks could equally well be applied to Chalmers' own paintings, or for that matter to works by McTaggart such as *The Storm* (catalogue no. 111), with its streaks of violet and other colours, for which there seems no obvious naturalistic explanation.

The fascinating thing about the Lauder group's attitude to colour is that it parallels so closely contemporary developments in France where

Dott's analysis of McTaggart's technique

Use of colour hatching

(42)

the preoccupation with making radiant colour out of broken interlaced touches of pure unmixed colour was traced, in, for example, Signac's treatise *D'Eugène Delacroix au Néo Impressionnisme*. There are two main differences between what was being done in France and in Britain. First the Lauder group's approach seems to have been entirely intuitive. If it had any base in physics or optics the artists kept remarkably quiet about it. Secondly the Scottish artists used very thin, often translucent paint, especially for the shadows – 'Keep your shadows transparent' said Pettie, 'and never lose the tooth of your canvas' – whereas the French employed solid opaque pigment throughout. The shadows, for instance, in a Monet are opaque, and often thicker than the lights. The Lauder group were amongst the last British painters to build their pictures out of the interplay of loaded and dilute, opaque and transparent pigment, for during the 1880s foreign technique was moving in. Sickert himself, despite the perceptive comment quoted at the beginning of this essay was an adherent of the French system.

Parallels between the Lauder group and French painters in the use of colour

Although the 1860s saw the scattering of the Lauder students their physical separation did not mean that they lost touch with each other. Those living in London made frequent visits to Scotland. They holidayed together and their letters to each other are full of references to other members of the group, descriptions of paintings, and accounts of public success. The Chalmers sale catalogue of 1878 shows that he owned pictures or drawings by MacWhirter, Hugh Cameron, Pettie and McTaggart. Sketches by Orchardson were owned by MacWhirter and McTaggart. MacWhirter owned Pettie sketches and Pettie's self portrait. McTaggart owned sketches by Pettie, including one that had formerly belonged to Chalmers. On several occasions two of Lauder's students collaborated on paintings, and after Chalmers' death Pettie completed several of his friend's pictures. Ideas on composition, technique or colour were passed to and fro between Lauder's students so that it sometimes becomes difficult to tell who was influencing whom. Chalmers, whose agonising and self-doubting temperament made him sometimes his own worst enemy, was never able to complete his *Legend* (catalogue no. 78), which therefore remains an impressive failure. Nevertheless, this picture, failure though it may be, was the pattern not only for Orchardson's *Story of a life* (catalogue no. 70) but also for Pettie's 1882 picture *The palmer* (illustrated by Martin Hardie in his *John Pettie*), and possibly for other works as well. Pettie, who was a more energetic and inventive, though a less highly refined artist than Orchardson, was the source for many of Orchardson's more daring compositional ideas. Even in the late works of many of these artists one can find passages which might have been painted by one of the others. For instance Pettie's *Laird* of 1878 (catalogue no. 81) has the distant hills and sky of Chalmers' landscapes, a cornfield behind the chief figure that echoes McTaggart's *Dora* of 1869 (catalogue no. 60), and a figure which might, without very close scrutiny, be passed off as a figure by Orchardson. A certain family resemblance between the 'touch' or painterly handwriting of the various artists can be found, right up to the end of their lives.

Lauder's students keep in touch with each other

They never forgot Lauder. Herdman spoke of him with affection in

an address to the Edinburgh art students prepared during the very last days of his life, and a Lauder owned by Chalmers was in the sale of his effects after his death. It had been acquired in 1865 while Lauder was still alive, but incapacitated by his stroke. Chalmers and McTaggart paid a

Chalmers buys a Lauder painting casual visit to the shop of the art dealer Dott, 'and while searching about we came upon a small bit of R.S.Lauder not very fine but it had the influence on me to make me ask Dott to show McTaggart another sketch ... *beautiful* Mc was delighted with it we both wanted it – when Dott brought out some others a head of Christ ... – well it comes to this that I fixed it and Mc has got the other ... The little bit Mc has got is remarkably fine also – not so complete as mine but much finer painting – I am however delighted I have got this bit in remembrance of R S L whom I admire exceedingly.'

List of Exhibits

* denotes works in the Aberdeen showing of the Exhibition.
C denotes a colour illustration.

1 Robert Scott Lauder
Self-portrait as a young man *

2 Robert Scott Lauder
Portrait of David Octavius Hill

3 Robert Scott Lauder
Henry Lauder

4 Robert Scott Lauder
Portrait of William Simson

5 Robert Scott Lauder
Portrait of Sir John Steell

6 Robert Scott Lauder
Sketch for The Bride of Lammermoor *

7 Robert Scott Lauder
A border keep

8 Robert Scott Lauder
A studio

9 Robert Scott Lauder
Portrait of William Leighton Leitch

10 Robert Scott Lauder
Self-portrait in seventeenth century costume *

11 Robert Scott Lauder
The artist's studio, Rome * C

12 Robert Scott Lauder
A contadina (not illustrated)

13 Robert Scott Lauder
A monk of the Santissima Trinita

14 Robert Scott Lauder
An Italian pilgrim

15 Robert Scott Lauder
An Italian goatherd *

16 Robert Scott Lauder
A view in the Roman Campagna

17 Robert Scott Lauder
A vineyard, Gensano *

18 Robert Scott Lauder
Portrait of John Henning

19 Robert Scott Lauder
Portrait of David Scott

20 Robert Scott Lauder
Portrait of Thomas Duncan

21 Robert Scott Lauder
Portrait of David Roberts * C

22 Robert Scott Lauder
Portrait of Professor John Wilson MA

23 Robert Scott Lauder
Study for Christ teacheth humility * C

24 Robert Scott Lauder
Christ teacheth humility

25 Robert Scott Lauder
Portrait of Walter Scott in the character of Peter Pattieson (not illustrated)

26 Robert Scott Lauder
The Fair Maid of Perth and the glee maiden at the dungeon wall

27 Robert Scott Lauder
Galeotti, the Astrologer, showing Lewis XI *the first specimen of printing* *

28 Robert Scott Lauder
Maître Pierre, the Countess of Croye, and Quentin Durward at the inn

29 Robert Scott Lauder
The Gow Chrom reluctantly conducting the glee maiden to a place of safety * C

30 Robert Scott
Two hands (illustrated in Essay, fig. b)

31 Robert Scott
A foot (illustrated in Essay, fig. b)

32 Plaster cast of Michelangelo's 'Dead Christ'
(not illustrated)

33 William Bell Scott
Study of a cast of Michelangelo's 'Dead Christ' (illustrated in Essay, fig. d)

34 Sir William Quiller Orchardson
Male nude

35 Sir William Quiller Orchardson
A female nude seated, with an earthenware jar

36 Unknown artist, pupil of Lauder
A group of casts from the antique (illustrated in Essay, fig. n)

37 William McTaggart
Prize drawing from the antique *

38 George Paul Chalmers
Prize drawing from the antique

39 William McTaggart
Two studies of a female nude model * C

40 William McTaggart
Life study of a nude model

41 Sir William Quiller Orchardson
Self-portrait in period costume

42 Sir William Quiller Orchardson
Wishart's Last Exaltation

43 William McTaggart
Going to sea

44 John Pettie
The prison pet

45 Hugh Cameron
Going to the hay * C

46 Alexander Hohenlohe Burr
The night stall

47 John Pettie
Cromwell's Saints *

106 John Pettie
Scene from 'Peveril of the Peak' * C
107 John Pettie
*Bonnie Prince Charlie entering the ballroom
at Holyrood*
108 Sir William Quiller Orchardson
*St Helena 1816 – Napoleon dictating to
Count Las Cases the account of his campaigns*
109 John MacWhirter
June in the Austrian Tyrol
110 William McTaggart
'Away o'er the sea' – Hope's whisper
111 William McTaggart
The storm C
112 William McTaggart
Blithe October *
113 William McTaggart
North Berwick Law from Cockenzie *
114 William McTaggart
Noontide, Jovie's Neuk C
115 Thomas Graham
The landing stage
116 Sir William Quiller Orchardson
Her mother's voice
117 Sir William Quiller Orchardson
Mariage de convenance – After! * C
118 William McTaggart
The 'dark' Dora (not illustrated)
119 Sir William Quiller Orchardson
The feather boa, or Lady in a brougham
(not illustrated)
120 Sir William Quiller Orchardson
Solitude *
121 Thomas Graham
Alone in London * C
122 Sir William Quiller Orchardson
The last dance C
123 William McTaggart
Autumn evening, Broomieknowe
124 John Hutchison
Portrait head of Robert Scott Lauder
(not illustrated)
125 George Paul Chalmers
Self-portrait *

126 George Paul Chalmers
Self-portrait * (not illustrated)
127 George Paul Chalmers
Self-portrait * (not illustrated)
128 Thomas Graham
Portrait of W. Q. Orchardson
129 George Paul Chalmers
Portrait of John Pettie
130 John Pettie
Portrait of the artist
131 Thomas Graham
Portrait of Sir William Quiller Orchardson
132 Sir William Quiller Orchardson
Self-portrait * (not illustrated)
133 John Pettie
Portrait of John MacWhirter *
134 Thomas Graham
Self-portrait *
135 Robert Herdman
Self-portrait *
136 John Pettie
Self-portrait *
137 John Pettie
*The Warrior – self-portrait in 16th century
armour* *
138 John Burr
Self-portrait *
139 George Paul Chalmers
Self-portrait
140 George Paul Chalmers
Portrait of John Pettie
141 John Pettie
Portrait of Chalmers (not illustrated)
142 John Pettie
Portrait of Orchardson
143 Sir William Quiller Orchardson
Portrait of Thomas Graham
144 John Burr
Self-portrait (not illustrated)
145 Peter Graham
Self-portrait *

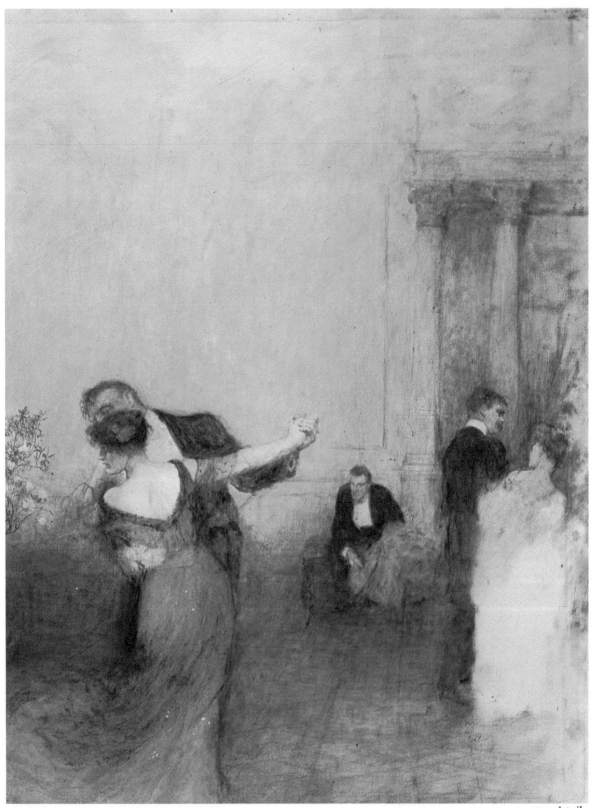

122 *detail*

Catalogue

All measurements are given in centimetres, height preceding width
* denotes works in the Aberdeen showing of the Exhibition.

ROBERT SCOTT LAUDER

1 Self-portrait as a young man *
Millboard : 18.7 × 15.3
Inscribed on the reverse: Scott Lauder /
RSA / Painted by himself / Bought from the /
collection of W. B. / Johnstone / Curator of
the Scottish National Gallery.
Scottish National Portrait Gallery

This was probably painted in the mid 1820s. A chalk
self portrait also in the collection of the Scottish
National Portrait Gallery is dated 1823 and shows
the artist without his side whiskers. W. B. Johnstone
(1804–68) artist and member of the RSA, was the
first curator of the Scottish National Gallery (in
1858) and would thus, as a colleague of Lauder,
working for the Board for Manufactures, have had
close contacts with him. He may have been given
the portrait by Lauder himself.

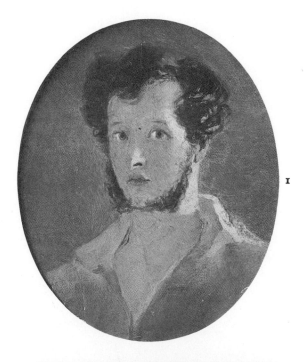

1

ROBERT SCOTT LAUDER

2 Portrait of David Octavius Hill
Canvas : 77.5 × 64.1
Lent by the National Portrait Gallery, London

D. O. Hill (1802–70) artist and photographer,
finished training at the Trustees' Academy in the
autumn of 1822 when Lauder first entered the
school. From 1830 Hill was secretary of the RSA,
and corresponded with Lauder about various
Academy affairs during the 1840s when Lauder was
resident in London. In 1851 Hill was a member of
the Committee which recommended Lauder's
appointment to the Directorship of the Trustees'
Academy. During the 1850s friendly feelings
between the two men seem to have cooled for
Lauder referred to Hill as 'a queer smaik' (English
'a sneaky untrustworthy fellow') in a letter to David
Roberts. This portrait, which shows Hill as young
and handsome, was probably painted in the years
1827–33, between Lauder's return from London
and journey to Italy. Several unidentifiable portraits
of artists were exhibited by Lauder between 1827
and 1829. The *D. O. Hill* which Rinder and McKay
(*The Royal Scottish Academy 1826–1916*, Glasgow
1917) date to circa 1829, may have been one of
them. It was exhibited again at the RSA in 1869 (the
year of Lauder's death) when it was described as
having been a gift from artist to sitter. It has been
assumed that this gift was made in 1869, but it is
far more likely that it was made when the portrait
was first painted rather than in the year of his death
when he had ceased to like the recipient.

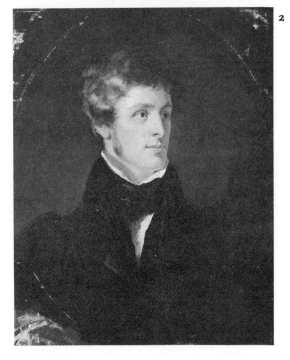

2

3

ROBERT SCOTT LAUDER

3 Henry Lauder
Canvas : 75 × 62.3
National Gallery of Scotland

Henry Lauder (1807–27) was four years younger
than Lauder. It is probable that the portrait was
painted in 1827 after Robert Lauder's return from
London. It is one of a group of three family portraits
by him, the others being of his father John Lauder
of Silvermills (Edinburgh City Art Gallery), and
his brother James Eckford. The portrait of Henry
is experimental in lighting, to a degree that might
not have been possible in a commissioned portrait,
and shows Lauder's strong painterly tendencies
already developed. There seems to have been a
tendency amongst the Scottish portraitists of the
1820s to exploit dramatic and unexpected lighting
effects, and the portrait of Henry Lauder has
several features in common with Geddes' portrait
of Charlotte Nasmyth, exhibited as *Summer* in the
Royal Institution, in 1828.

ROBERT SCOTT LAUDER

4 Portrait of William Simson
Canvas : 91.5 × 72.5
Lent by the Royal Scottish Academy

William Simson (1800–47) was a painter, mainly
of landscapes, three years older than Lauder. He
was one of the foundation members of the RSA in
1826, immediately withdrew, but subsequently
again became a member in 1829 at the same time
as Lauder, William Allan, Thomas Duncan, John
Steell and David Scott. At first Simson worked in
Edinburgh. He followed Lauder to Italy in 1836
and then moved, like Lauder, to London in 1838.
In 1841 Lauder praised one of Simson's pictures,
Mary Queen of Scots returning from the chase, in a
letter to D.O.Hill. Simson's youthful appearance
in Lauder's portrait indicates a date in the 1820s. It
was presented to the RSA in 1856 by the sitter's
brother David Simson, which suggests that Lauder
had probably given it to the sitter.

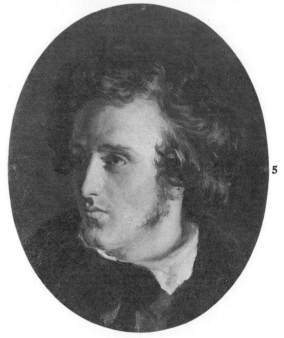

ROBERT SCOTT LAUDER

5 Portrait of Sir John Steell
Canvas, oval : 21.1 × 17.3
Scottish National Portrait Gallery

John Steell, sculptor (1804–91), was a year younger
than Lauder and became a member of the RSA at the
same time, in 1829. David Scott (in William Bell
Scott, *Memoir of David Scott, RSA*, Edinburgh
1850) mentions a visit paid by Lauder and Steell
to his studio in 1831, and the two men were evidently
friends. In 1851–2 Steell was a member of the com-
mittee which recommended Lauder's appointment
as Director of the Trustees' Academy. In his report
to the Board on this occasion Steell suggested that a
teacher with the special ability to infuse the
'Promethean fire' of the fine arts into the design
course was required. Steell was the leading Scottish
sculptor of his day, and executed many of the public
monuments of Edinburgh, including the equestrian
statue of the Duke of Wellington at Register House,
the figure of Scott for the Scott monument, the

seated figure of Queen Victoria on the Royal Institution (now the RSA) building, and the standing figure of 'Christopher North' (Professor Wilson) in Princes Street. This last makes an interesting comparison with Lauder's portrait of the same sitter (catalogue no. 22). The portrait of Steell was painted in 1832 and is a sensitive and lively rendering of his expression. It was presented to the National Gallery of Scotland, in 1893 by Steell's sister, which suggests that Lauder, as was his habit when painting friends, had originally given the portrait to his sitter.

ROBERT SCOTT LAUDER

6 Sketch for The Bride of Lammermoor *
A second sketch for the same subject is on the reverse
Millboard : 14.5 × 20.25
Lent by Mr & Mrs Richard Emerson

Scott was still writing anonymously when he issued *The Bride of Lammermoor* in 1819. In the introduction, he pretended it had been composed by (the imaginary) Peter Pattieson in competition with (the equally imaginary) Dick Tinto, artist. Tinto had supposedly painted a picture showing a confrontation between a dark cloaked man and a shrinking girl, surrounded by other figures. He claimed that his painting was completely self explanatory and revealed the whole train of preceding events at a glance. Pattieson disagreed and the novel of *The Bride* was the result. In it the events depicted by Tinto form the most critical point of the story, but are only reached just before the conclusion. Lauder thus accepted something in the nature of a challenge issued by a writer to painters. His own finished *Bride of Lammermoor* exhibited at the RSA in 1831 (Dundee City Art Gallery) is a recreation of Tinto's picture. The hero, Edgar of Ravenswood, arrives from abroad at the precise moment when his fiancée Lucy has succumbed to parental pressure and signed a contract of marriage with his rival. The madness of Lucy, her death and the death of Ravenswood, follow in quick succession. Lauder's sketch and finished picture of 1831 depend fairly heavily in style and arrangement on William Allan's painting of *John Knox reproving Mary Queen of Scots*. When in Rome Lauder painted a second, more luxuriant version of the subject (now in a private collection) which can be seen in the background of his *Roman Studio* (catalogue no. 11).

ROBERT SCOTT LAUDER

7 A border keep
Canvas laid on panel : 40.6 × 53.3
Inscribed on the reverse: A border keep by R. S. Lauder
Lent by James Holloway

The castle is almost certainly Newark on the river Yarrow, the castle Scott used for the setting of *The lay of the last minstrel*. This castle was painted, from the other side, by Lauder's father in law, Thomson of Duddingston.

No precise date can be assigned to this picture. There are hints of Thomson of Duddingston's influence which suggests that it may be an early work, predating Lauder's visit to Italy. On the other hand, it is close in character to a contemporary description of a landscape, *Sunset on the Tweed*, exhibited by Lauder at the RSA in 1862 (163). However, since Lauder after his 1861 stroke was no longer painting anything, the *Sunset* may have been an earlier, even a very early painting. On the whole it is easier to regard the *border keep* also as an early work. The sunset sky was a favourite effect of Lauder's and he painted similar sunsets behind some of his late religious pictures.

ROBERT SCOTT LAUDER

8 A studio
Millboard : 25 × 20.4
Lent by the family of the artist

The style suggests an early work, painted shortly before or during the artist's visit to Italy. The two figures are possibly intended for the artist himself and his wife Isabella, daughter of Thomson of Duddingston.

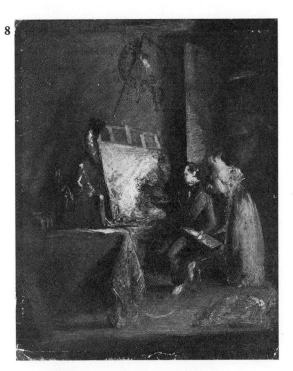

he was attracted and influenced – just like Lauder in Edinburgh – by Smirke's illustrations to *The Arabian Nights*, and David Roberts' theatrical scenery. He took up scene painting himself, eventually obtained an introduction to Roberts and moved to London in 1830. It is difficult to date Lauder's portrait precisely, but as Leitch visited Rome in 1834–5 whilst Lauder was living there, it is reasonable to conjecture that it was painted in Rome. At an earlier period whilst Leitch was in Glasgow, and later at Cumnock painting snuff boxes, it is unlikely that he encountered Lauder. On the other hand, a date after Lauder's return from Rome in 1838 seems equally unlikely in view of the sitter's youthful appearance. D.O. Hill's calotypes of Leitch (taken circa 1845) show an older face with harsher lines, but the same long, narrow and bony structure.

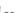

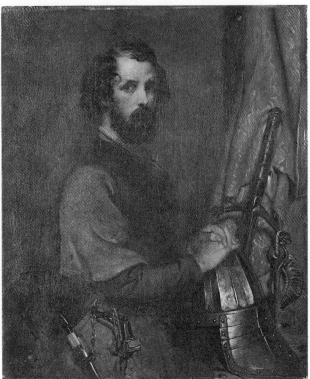

ROBERT SCOTT LAUDER

9 Portrait of William Leighton Leitch
Canvas : 24.7 × 21.5
Lent by the Royal Scottish Academy

William Leighton Leitch (1804–83), a watercolour painter who later gave lessons to Queen Victoria, was a year younger than Lauder. Apprenticed to a Glasgow weaver when about fifteen years old,

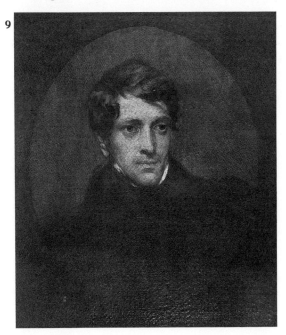

ROBERT SCOTT LAUDER

10 Self-portrait in seventeenth century costume *
Canvas : 40 × 34
Signed and inscribed: R.S. LAUDER, ROME
Lent by the Patrick Allan-Fraser of Hospital-field Trust, Arbroath

This is the traditional title but the costume suggests the late middle ages or sixteenth rather than the seventeenth century. The helmet also appears in the foreground of Lauder's painting of his *Roman studio* (catalogue no. 11).

ROBERT SCOTT LAUDER

11 The artist's studio, Rome *
Canvas : 48.3 × 63.5
Lent by the family of the artist

In the foreground is the same helmet that appears in the artist's Roman *Self Portrait* (catalogue no. 10). In the background is the second version of Lauder's two paintings illustrating Scott's *Bride of Lammermoor* (see under catalogue no. 6). The other paintings stacked behind it are at present unidentified. This painting was retained by the artist and is probably the one he exhibited at the RSA in 1860 (213), the same year in which he exhibited his *Vineyard, Gensano* (catalogue no. 17). Like the *Contadina* (catalogue no. 12) it is painted over a dark ground. It is inscribed on a label on the reverse: The Studio of Robert Scott Lauder / Rome – R.S. Lauder RSA / Lent by John Hutchison RSA.

Hutchison was one of Lauder's pupils and executed the marble bust for Lauder's tomb in Warriston Cemetery (see under catalogue no. 124).

11

ROBERT SCOTT LAUDER

12 A Contadina
Canvas : 53 × 29.5
Lent by the family of the artist

Painted whilst the artist was in Italy (1833–38). A watercolour version of this subject exists in an album of studies supposed to be by Lauder (NGS collection). It is probable, however, that the watercolour is not Lauder's preparatory study for the oil sketch – itself only a study – but a copy made by his wife Isabella, the daughter of the painter Thomson of Duddingston, also an amateur artist. This oil study appears to be painted over a dark ground.

ROBERT SCOTT LAUDER

13 A monk of the Santissima Trinita
Paper laid on canvas : 39.5 × 27
Inscribed: ORDINE della Santissima Trinita
Lent by the family of the artist
Painted whilst the artist was in Italy 1833–38

ROBERT SCOTT LAUDER

14 An Italian pilgrim
Paper laid on canvas : 33.8 × 27.8
Lent by the family of the artist
Painted whilst the artist was in Italy 1833–38.

13

14

ROBERT SCOTT LAUDER

15 An Italian goatherd *
Canvas : 43.5 × 31
Lent by the family of the artist

This study, painted whilst Lauder was in Italy,
(1833–38), was later utilised by him for one of the
figures in his oil painting *Italian goatherds entertain-
ing a Brother of the Santissima Trinita*, exhibited at
the RSA in 1841 (369) and engraved in 1843 for the
members of the Royal Association for the promotion
of the fine arts in Scotland.

15

ROBERT SCOTT LAUDER

16 A view in the Roman Campagna
Canvas : 38.7 × 90.5
Lent by Duncan MacMillan

Painted by the artist whilst in Italy 1833–38, this
remained in his own possession, and subsequently
that of his family, as indicated by an old label on
the stretcher inscribed: *The property of Mrs Lauder*

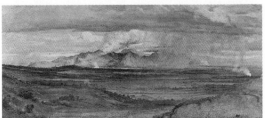

16

(55)

Thomson. In the late 1850s, and after his stroke incapacitated him in 1861, Lauder regularly exhibited his early works at the RSA. These included some Italian views, of which four were views of the Roman Campagna, from Frascati, from Villa Rufinella, from Villa Albani and from Albano. It is very possible that this painting was one of these late exhibits. It has suffered considerable damage over the years – possibly through overcleaning – especially in the foreground – but enough remains to show Lauder's dramatic and sensitive treatment of space and atmosphere. Recent examination of the blue pigment in the distant mountains and sky indicates that it is genuine ultramarine, an extremely expensive colour. The use of this pigment might perhaps have been suggested to Lauder by study of the landscape backgrounds of Titian and the other Venetians.

ROBERT SCOTT LAUDER

17 A vineyard, Gensano *
Canvas : 47 × 37
Lent by Aberdeen Art Gallery and Museums

Although painted whilst Lauder was in Italy in 1833–38, this was not exhibited until 1860 when he showed it at the RSA (196). From 1859 onwards – and especially after his stroke in 1861 when he ceased altogether to produce new pictures – Lauder regularly exhibited works painted at a much earlier period and which he must have retained in his own hands. This sketch subsequently belonged to

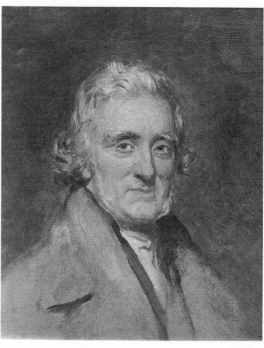

17

George Paul Chalmers' friend, the painter George Reid, who bequeathed it to Aberdeen Art Gallery.

ROBERT SCOTT LAUDER

18 Portrait of John Henning
Canvas : 23.5 × 19.7
Scottish National Portrait Gallery

18

John Henning (1771–1851) was a Scot from Paisley who learnt to model in bas relief on a small scale from James Tassie. He moved to London in 1811 where he made drawings of the newly arrived Elgin Marbles, and subsequently produced miniature copies of the Parthenon friezes, engraved in intaglio upon slate, and then cast in enamel and stucco. Henning's profound admiration for these works of Greek art would have endeared him to Lauder who shared his reverence for the Marbles. Henning's portrait must either have been executed in London after Lauder's return from Italy in 1838, or possibly in Edinburgh just before Lauder's departure at the end of 1833. Any attempt to fix the date must depend, in the absence of other evidence, on whether the sitter appears more like a man of 64, or one of 69. On the whole the later dating seems more probable.

ROBERT SCOTT LAUDER

19 Portrait of David Scott
Canvas : 68.6 × 52.1
Inscribed: DAVID SCOTT / PAINTED / BY / R.S.LAUDER RSA / 1839
Scottish National Portrait Gallery

David Scott, artist (1806–49), was a near contemporary of Lauder. Though three years younger than Lauder, Scott began studying at the Trustees' Academy several years before him. Obsessive, gloomy, and self-centred, Scott clung with fanaticism to historical subject matter and a style of painting that aroused little sympathy or interest amongst the general public. Most of Scott's comments on his fellow artists were sarcastic or embittered, and he recorded with contempt how Lauder, on looking at Scott's picture *Streaking the corse* (i.e. laying out the dead body), advised him to make it less frightful 'or you may do harm to the ladies'. Friendly relations must nevertheless have existed between the two men, for Lauder brought family letters to Scott in Italy in 1833, together with a copy of a poem by William Bell Scott, his younger brother. Scott visited Lauder's Italian studio, noting with probable censure that Lauder was engaged in painting portraits. This portrait of Scott, painted after Lauder's return from Italy, must have been carried out when Scott paid the visit to London to which Bell Scott refers in a note on one of the drawings in the NGS collection.

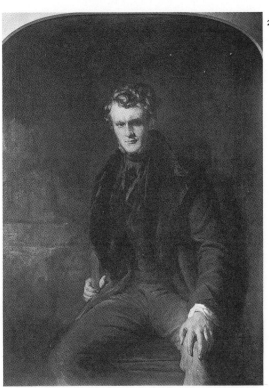

20

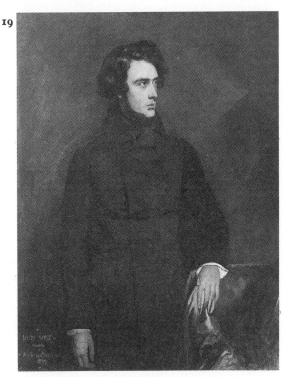

19

Academy under William Allan, and together with Allan and Lauder was amongst the group of artists who adhered to the Royal Institution until 1829, when their position became so intolerable that they left it for the Royal Scottish Academy. Duncan's masterpiece, *Anne Page and Slender* of 1837 (National Gallery of Scotland) was discussed by Lauder (who had not seen it) in one of his letters from Italy to D.R.Hay. It is evident from the references made to Duncan that Lauder was fond of him and admired his painting. In 1844 Duncan, following Allan, was briefly, until his death, master of the Trustees' Academy. Lauder's painting, judged on stylistic grounds, is probably contemporary with his 1839 portrait of David Scott (catalogue no. 19). Duncan's *Self portrait* of 1844, and D.O.Hill's calotypes of about the same date, show a slightly older face and more receding hairline than in Lauder's portrait, but the square and determined position, out-thrust arms, and tucked in chin painted by Lauder also appear in one of the calotypes and were probably characteristic of the sitter's normal attitude.

ROBERT SCOTT LAUDER

20 Portrait of Thomas Duncan
Canvas: 71.1 × 53.3
Scottish National Portrait Gallery

Thomas Duncan, artist (1807–45), was four years younger than Lauder. He studied at the Trustees'

ROBERT SCOTT LAUDER

21 Portrait of David Roberts *
Canvas: 133 × 101.5
Scottish National Portrait Gallery

David Roberts (1796–1864), artist and traveller, was seven years older than Lauder, and for many

21

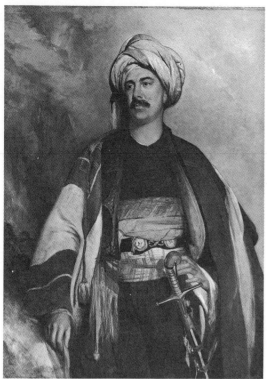

North' was a poet, and also one of the notoriously abusive critics involved with *Blackwood's Magazine*. In 1820 Wilson obtained the Chair of Moral Philosophy at Edinburgh University, to which post he was, in character and academic attainments, totally unsuited. He made his mark at the University less for the content of his lectures than for rhetoric with which he delivered them. His was an outsize personality. Extremely tall and broad chested, legendary for extravagant abilities as an athlete and drinker, wildly informal (for the day) in his dress, he was tremendously popular with his students. Lauder's Michelangelesque portrait was exhibited at the RA, London in 1843 and was greatly disliked by David Roberts. It antedates D.O. Hill's calotyped portraits of Wilson by about a year. In the calotypes, the 'beautiful leopard' – Wilson's pseudonym in one of the early *Blackwood's* pieces – is bleakly revealed as having become fat, bald and generally gone to seed. Using this unpromising physical original, and without marked idealisation of any features, Lauder managed to evoke a magnificent and powerful presence that sums up all we know of Wilson's public image. It is a far superior rendering to Watson Gordon's reticent and rather dull portrait of 1829 (SNGP) and an interesting complement to Thomas Duncan's little informal cabinet portrait of Wilson as 'Christopher North' the sportsman, in his shooting jacket (SNPG).

ROBERT SCOTT LAUDER

23 Study for Christ teacheth humility *
Canvas : 31.1 × 56.5
National Gallery of Scotland

This study contains the grouping of figures round Christ that Lauder retained for the large version, together with two extra groups to the left and right. That on the right was used for the version formerly in Arbroath Library but was eliminated in the final composition of catalogue no. 24. Lauder wrote that he had made two sketches. One was engraved in *The Illustrated London News* for 28 April 1849, and is now lost. It differed from the present study in several respects, though both sketches had a group of sick people brought by their friends so that Christ might see them. In the large version of 1847, this group was left out.

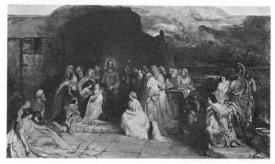

23

years a close friend. This friendship, which may have begun about 1818, when Roberts was painting theatre scenery, and which was a source of encouragement to Lauder in adopting the career of an artist, lasted until the later 1850s when unrepaid loans of money, made by Roberts to Lauder, led to a souring of the relationship. Both men shared the friendship of David Ramsay Hay for whom this portrait was painted. On 13 February 1840 Roberts wrote to Hay: 'I gave Lauder the last sitting or rather standing today – I of course can say nothing as to likeness, but as far as the metamorphosis of an eastern dress will allow I am told (it) is good – it is broad and for Lauder dashingly painted and I think will tell in the Exhibition.' The portrait was offered as a present by Hay to Roberts in 1848, and was accepted, but never removed from Hay's house. In 1859 Roberts disclaimed any further interest in it and its creator.

What Roberts called 'the representation of the Edinburgh callant in that outlandish dress', was in fact painted from the costume which he actually adopted whilst travelling and sketching in the Middle East on his tour of 1838–39.

ROBERT SCOTT LAUDER

22 Portrait of Professor John Wilson M.A.
Canvas : 239 × 147 .
Lent by the University of Edinburgh

Professor Wilson (1785–1854) or 'Christopher

22

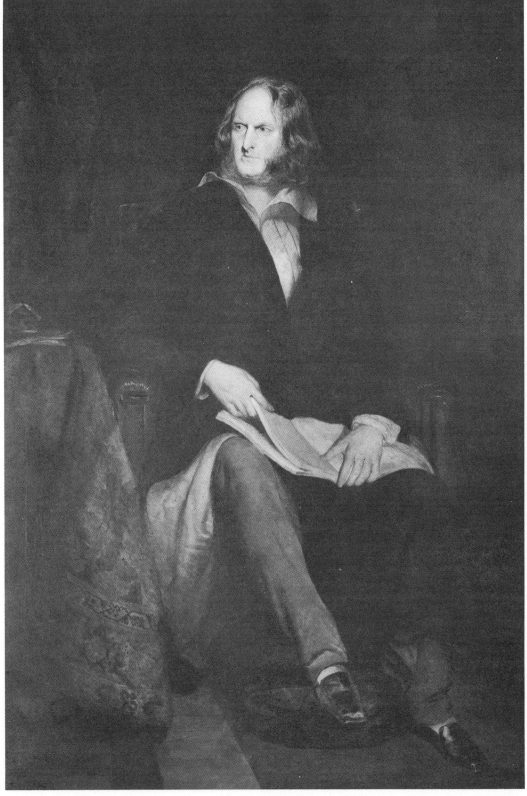

The sketch is a particularly good example of Lauder's taste for rich colour, especially in the use of red to define some of the figures, a device that can also be seen in the outline of the hands in the Roberts portrait (catalogue no. 21).

ROBERT SCOTT LAUDER

24 Christ teacheth humility
Canvas : 234 × 353
National Gallery of Scotland

This illustrates Matthew 18. The Disciples came and asked Jesus who would be greatest in the kingdom of heaven, and were told that unless they humbled themselves like little children they would never enter it. The painting was prepared by Lauder for the competition, organised by Her Majesty's Commissioners on the fine arts, to find pictures suitable for hanging in the new Houses of Parliament. Two years were allowed for preparation, and the finished works were exhibited in Westminster Hall in 1847. The choice of subject matter had been left to the artists, and both it, and the sizes of the pictures submitted, varied very considerably. Lauder did not win a premium.

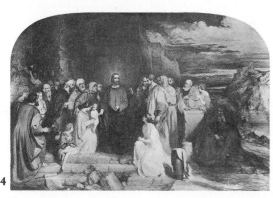

24

There is another version of the picture (formerly Arbroath Library), which Lauder described in a letter of 1854 as an earlier version, 'put aside, as I believed the arrangement of the Design might be much improved by making a more formal composition, better adapted to the dignity of the subject. This I did by placing the Saviour and the figures about him in the centre, that group in the other being at the left side: with the exception of this group I believe there is no resemblance between the pictures. The design of the one here terminates in the figure of Judas, in the other there are a number of Roman soldiers, women and children. The figures on the left of the picture here (i.e. in the NGS) such as the man who has dropped the tables of the law . . . are not in the other work.'

Besides these two large versions of the design there were also two small oil sketches, catalogue no. 23, and another, now lost.

Members of the artist's family who posed for some of the figures in the picture, included his wife, his daughter Isabella, and his sons Henry and Robert.

The conception and treatment suggests the influence of Wilkie's unfinished *Knox dispensing the Sacrament*. The design may be partly based on Rembrandt's etching of Christ healing the sick.

The picture was bought by the Association for the Promotion of the Fine Arts in Scotland, in 1849.

ROBERT SCOTT LAUDER

25 Portrait of Walter Scott in the character of Peter Pattieson
Black and red chalk heightened with white on grey paper : 46.6 × 35.4
Private collection

Lauder is said to have been encouraged to enter the Trustees' Academy by Walter Scott – though there is now no evidence of this. However, his friendship with the painters William Allan and Thomson of Duddingston, both friends of Scott, would very probably have brought Lauder into contact with the author during the later 1820s even if he had not met him earlier. This seems to be a posthumous likeness of Scott, and is probably the picture, or a study for the picture, shown by Lauder at the Free Exhibition in 1848.

The picture on the left, at which Scott is peering, is one of Lauder's own *Brides of Lammermoor* (catalogue no. 6). In 1871 the drawing was owned by the publisher's son, John Blackwood, who lent

26

it to the Scott exhibition. Scott had invented the character of Peter Pattieson as a pseudonym for himself, the anonymous author of *The Bride of Lammermoor*. Pattieson and Dick Tinto (an artist, also invented by Scott), have an argument over the relative merits of writing and painting in conveying the essentials of a story. Tinto claims that, 'Description was to the author of a romance exactly what drawing and tinting were to a painter; words were his colours', and to prove his point displays before the incredulous Pattieson his sketch of the key episode in *The Bride of Lammermoor*. Since Lauder has drawn Scott as Pattieson, and used his own *Bride* picture for Tinto's sketch, one would expect Tinto to be a self-portrait. The features nevertheless do not seem very like Lauder's and this must remain a matter for conjecture. In style this drawing bears a close resemblance to the late drawings of Wilkie which Lauder could have seen in the Wilkie sale of 1842.

ROBERT SCOTT LAUDER

26 The Fair Maid of Perth and the glee maiden at the dungeon wall
Canvas: 101.5 × 75.5
Signed and dated: R. S. Lauder / 1848
Lent by the Stirling Smith Art Gallery and Museum.

Scott's novel *The Fair Maid of Perth* is a mixture of authentic history and fiction. Set in the fourteenth century, it describes how King Robert III's eldest son the Duke of Rothsay was starved to death in the dungeon of Falkland Palace at the instigation of his uncle the Duke of Albany. Scott used the story that Rothsay had been fed for a time by two women from outside the prison as a pretext for making his fictitious heroine Catherine Glover participate in the events that preceded Rothsay's death. In Lauder's picture Catherine, a gentle girl with a loathing for violence, and Louise the glee maiden, a wandering musician, discover the imprisonment of Rothsay by hearing his groans coming through a crack in the prison wall. Lauder exhibited his picture at the RA in 1847 (490) with a quotation from Scott. He was clearly interested in the pictorial possibilities of the rich silks and furs worn by the two heroines and in the way these could reveal their contrasting characters and social positions. Lauder clearly knew very little about what the costumes of medieval Scotland had really looked like. The application of paint alternates between the thinness and translucency of a watercolour technique, and a more loaded impasto in the highlights.

ROBERT SCOTT LAUDER

27 Galeotti, the Astrologer, showing Lewis XI the first specimen of printing *

27

Canvas: 127 × 104.7
Signed and dated: R. S. Lauder / Pinxit 1850
Lent by Perth Museum and Art Gallery

This and catalogue no. 28, also an illustration to Scott's *Quentin Durward*, were both exhibited at the RSA in 1851. Scott's novel is a story of political intrigue and romantic adventure set in fifteenth century France. Louis XI of France is portrayed by Scott as a sinister and Machiavellian character who deliberately embroils the innocent Scottish hero Quentin in his potentially deadly schemes. Before embarking on his evil project, the King, who is represented as extremely superstitious, feels bound to consult Galeotti his Italian astrologer. Scott describes at length the exotic and weird furnishings of Galeotti's apartment, its carvings, tapestries, oriental carpet, mathematical instruments, Turkish scimitar, gigantic suits of armour, heathen idol, classical sepulchral vase, cabalistical manuscripts, and even a specimen of the newly invented printing press. Galeotti predicts the vast social changes that this, and other scientific inventions will bring, and is requested by the King to concentrate instead on producing Quentin's horoscope.

Lauder's use of richly glowing colour, and the contrasting surfaces of velvet, steel, or fur, together with the exotic range of collector's bric-a-brac, and slightly mysterious atmosphere, had an almost immediate impact on such Scottish artists as Fettes Douglas in whose work the combination of rich colour, extraordinarily assorted antique objects, learned medieval men, and magic, were to become standard items of subject matter.

(61)

ROBERT SCOTT LAUDER

28 Maître Pierre, the Countess of Croye, and Quentin Durward at the inn
Canvas : 106.5 × 137.5
Lent by the Forbes Magazine Collection, New York

28

This picture, together with catalogue no. 27, also illustrating a scene from Scott's novel of *Quentin Durward*, was exhibited at the RSA in 1851. The seated man on the left is the disguised King Louis XI of France, concocting a stratagem which – if successful – is intended to embroil both figures on the right, ruining the girl and leading to the hero Quentin's death. In the event the plot is not successful. The layout and dramatic situation in this picture suggest that Lauder had been strongly affected by the appearance of Millais' first Pre-Raphaelite picture in the Royal Academy of 1849, *Lorenzo and Isabella*, and that he was echoing, maybe quite unconsciously, some of the main elements of structure, situation, and costume used by Millais. The stories told by both artists are parallel in theme. In each picture a villain is shown brooding over the murder of one of a pair of youthful lovers who, innocent of approaching disaster, are totally occupied with each other, linked together by the motif of a plate of fruit. In each picture the absorbed villain and unconscious victims occupy opposite sides of the picture, and there are further parallels in the dress and posing of the figures. Lauder's dark background and rich glowing colour are, however, quite unlike the pale rather airless setting and almost strident colour contrasts of Millais.

ROBERT SCOTT LAUDER

29 The Gow Chrom reluctantly conducting the glee maiden to a place of safety *
Canvas : 91 × 73. 'Gow Chrom' is gaelic for 'the bandy-legged smith'.
Lent by the Patrick Allan-Fraser of Hospitalfield Trust, Arbroath

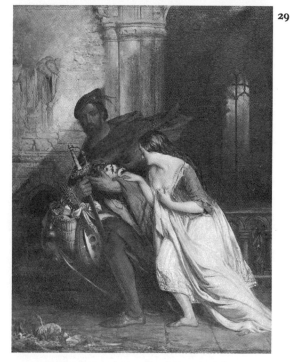

29

This scene from Scott's medieval novel *The Fair Maid of Perth*, shows the embarrassment of the hero, an armourer of Perth, when obliged by circumstances to act as public escort to Louise the glee maiden, an itinerant street musician and entertainer of very doubtful virtue. He is afraid that a report of his behaviour will reach his intended fiancée who is bound to misunderstand his motives. This picture exhibited at the RSA in 1854 (54) was Lauder's second version of the subject. The first, painted in 1846, became the property of an Art Union prizewinner and was exported in 1847 to Australia where it was enthusiastically received.

The curious sagging posture and trailing drapery of the glee-maiden may reflect Lauder's enthusiasm for the Elgin marbles where such poses are used as a convention to express forward movement (e.g. the figure of Iris from the East Pediment).

Orchardson's later painting from Scott's novel *Peveril* (catalogue no. 75) seems to echo Lauder's conception of a reluctant escort and shrinking companion.

DRAWINGS AND PAINTINGS ASSOCIATED WITH THE TRUSTEES' ACADEMY

ROBERT SCOTT

30 Two hands
Red chalk : 24.2 × 29
National Gallery of Scotland

Executed at the Trustees' Academy in 1788, under the Mastership of David Allan. This would have been copied from a drawing or engraving, and is an example of 'outline drawing from the flat' as practised by the elementary students (illustrated in Essay, fig. b).

ROBERT SCOTT

31 A foot
Red chalk : 18.5 × 30.2
Inscribed: *No. 13*
National Gallery of Scotland

Executed at the Trustees' Academy in 1788, under the Mastership of David Allan. This was almost certainly copied from a drawing or engraving, and is an example of 'shaded drawing from the flat' as practised by the elementary students (illustrated in Essay, fig. b).

34

32 Plaster Cast of Michelangelo's 'Dead Christ'
Lent by the Governors of Edinburgh College of Art

This cast was the property of the Trustees' Academy. It was drawn by William Bell Scott in 1827 and later by William McTaggart in his prize drawing from the antique of 1855 (catalogue no. 37).

WILLIAM BELL SCOTT

33 Study of a cast of Michelangelo's 'Dead Christ'
Black chalk heightened with white on grey paper : 37 × 51.7
Inscribed: Trustees' Academy
National Gallery of Scotland

This was drawn in 1827, under the Mastership of William Allan. The standard of work should be compared with the antique drawings produced under Lauder (catalogue nos. 36, 47 and 38) (illustrated in Essay Section, fig. d).

WILLIAM QUILLER ORCHARDSON

34 Male nude
Pencil : 71.1 × 50.8
Inscribed: Academy drawing by W.Q. Orchardson RA to Mr Stewart from J.H. Cranstoun.
Lent by the City of Dundee Art Gallery

William Hardie has suggested a date for this drawing of circa 1850. That would place it towards the end of Orchardson's training at the Trustees' Academy, under the Mastership of Ballantyne. In the 1849–50 session, and again in the 1850–51 session, Orchardson took the first prize for life drawing. This, though not necessarily one of the drawings for which he was awarded a prize, shows the standard of work attained. J.H. Cranstoun, who formerly owned the drawing was a friend of Orchardson, whose portrait is catalogue no. 65.

WILLIAM QUILLER ORCHARDSON

35 A female nude seated, with an earthenware jar
Oil on paper laid on canvas : 29.1 × 43.8
Inscribed on a label: William Orchardson 1851
Lent by James Holloway

This was painted the year before Lauder accepted the Directorship of the Trustees' Academy. Orchardson had been one of the Academy's star pupils under the Mastership of Ballantyne, dividing the main prizes with Robert Herdman. In the 1850–51 session he received the first prize for drawing from the life and the third prize for painting

35

from the life. In the 1851–52 session he achieved
first prize for painting from the life, and in 1851 he
and Herdman, together with other prize pupils
were given two pounds, ten shillings each, to visit
the Great Exhibition in London. Although at the
time of Lauder's arrival, Orchardson had really
finished his training, he did return to benefit from
Lauder's advice. Pettie, McTaggart and the other
younger men saw little of him at this stage. McTag-
gart later told Martin Hardie, 'Orchardson was the
best student of his time – his academic work was
over before we, who were mostly younger, began.
. . . Naturally the older artist had upon us all a
thankfully acknowledged influence.'

36 A group of casts from the antique
Chalk : 81.3 × 109
*Lent by the Governors of Edinburgh
College of Art*

This is the type of highly finished drawing from the
antique which Lauder's pupils used to submit for
the annual Trustees' Academy competitions.
Similar prizewinning drawings by McTaggart and
by Chalmers are catalogue nos. 37 and 38. This
drawing, on which the student was probably
occupied for nearly a year, is executed in the 'stump'
technique, the lines of shading being smudged
together to produce a tonal effect. Lauder was
unique for his day in insisting that the student
should draw groups of casts rather than isolated
figures, believing that this would help him to grasp
principles of grouping, composition and the
relationships between figures. The casts in the
Trustees' Academy's Statue Gallery were crowded
into a 'queue' that ran the length of the gallery. As
they were mounted on castors Lauder was able to
re-arrange them periodically. These arrangements
seem to have been formed entirely for pictorial
effects. No attempt was made to organise the statues
according to historical periods or national schools
(illustrated in Essay, fig. n).

37

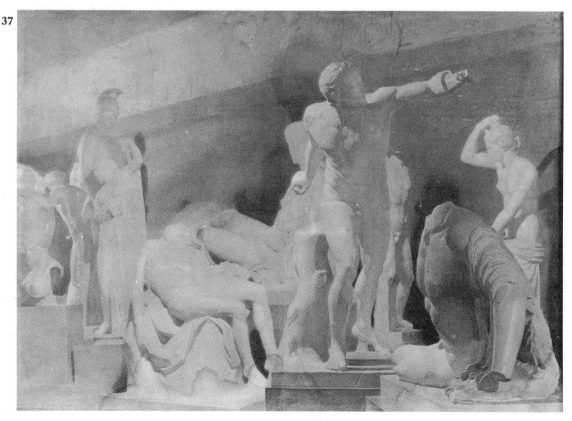

WILLIAM McTAGGART

37 Prize drawing from the antique *
Pencil or chalk on buff paper : 75 × 106
(sight size)
*Lent by The Governors of Edinburgh
College of Art*

This drawing, with which McTaggart took second
prize for drawing from the antique in the 1854–55
session at the Trustees' Academy, is illustrated by
Caw in his 1917 monograph on McTaggart.

GEORGE PAUL CHALMERS

38 Prize drawing from the antique
Pencil or chalk on buff paper : 76 × 106
(sight size)
*Lent by the Governors of Edinburgh
College of Art*

This drawing, with which Chalmers took first prize
for drawing from the antique in the 1855–56
session at the Trustees' Academy, is illustrated by
Pinnington in his 1896 monograph on Chalmers.
It is a slighter, more insubstantial drawing than
that by McTaggart or the draughtsman of no. 36.

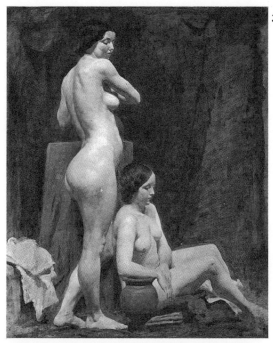

39

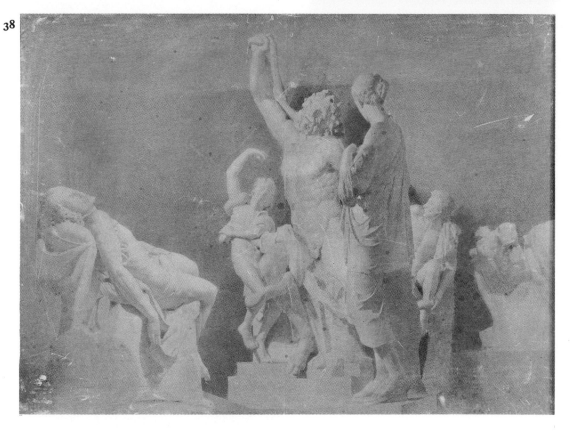

38

(65)

WILLIAM McTAGGART

39 Two studies of a female nude model *
Canvas : 61 × 58
National Gallery of Scotland

These studies executed at the Trustees' Academy
are probably contemporaneous with catalogue no.
40, and can therefore be dated circa 1855. The
resemblance between the two figures, together with
the lack of any contact or relationship – i.e. of cast
shadows – between them, suggests that they are in
fact the same model. The artist may have completed
the standing girl and then, realising that he still
had space available, have added her, seated, from a
later pose. The very thin paint, craftsmanlike
technique, and close attention to reflected lights and
the colours of the shadows make this a remarkable
contrast to the artist's later works. It is interesting
to see the resemblance to the Orchardson nude,
painted a few years earlier (catalogue no. 35).
McTaggart's *Studies* together with catalogue no. 40
remained in the possession of his family until 1981.

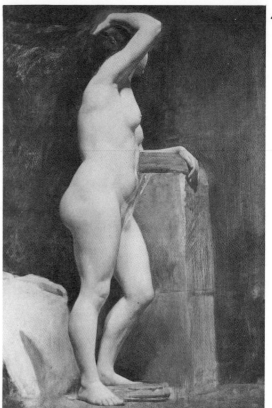

40

WILLIAM McTAGGART

40 Life study of a nude model
Paper laid on canvas : 55.8 × 35.5
Lent by the Fine Art Society

This was painted by the artist whilst studying under
Lauder at the Trustees' Academy. It remained,
together with the double life study (catalogue no.
39), and a third life study for which the artist won a
prize in 1855, in his own possession, passing eventu-
ally to his grandson, Sir William MacTaggart. The
high standard of craftsmanship, thin and smooth
application, attention to delicate details both of
form and of local and reflected colours, are in
striking contrast to the later free and sketchy land-
scapes and in which the treatment of the human
figure appears – at least to a superficial glance – as
careless and perfunctory.

41

WILLIAM QUILLER ORCHARDSON

41 Self-portrait in period costume
Panel : 25.3 × 20
*Lent by The Trustees of the Orchar
Art Gallery*

This was described in 1897 by J. S. Little as having been painted when Orchardson was a pupil of Robert Scott Lauder. The features, especially the forehead and nose, are so like those in other portraits of the artist as to justify the view that this is a self portrait of a sort, but the pose and costume require some explanation. A subject picture by Orchardson of about the same period, *The weary coble o' Cargill*, contained a full length figure in similar pseudo-medieval costume and almost identical pose. It is reasonable to suppose that the *Self portrait* is related to this composition and may perhaps be an elaborated study for it. Orchardson may have been influenced to a slight degree by the odd forward

stooping pose, and the lighting of Millais' *Ferdinand and Ariel* exhibited at the RSA in 1854, which suggests a date of about 1854 for the *Self portrait*.

WILLIAM QUILLER ORCHARDSON

42 Wishart's Last Exaltation
Canvas : 101.5 × 127.5
Lent by the University of St Andrews

This was exhibited at the RSA in 1853. According to the artist's daughter it was seen by Robert Scott Lauder just after it had been sketched in, when only one head was painted. Stimulated by Lauder's interest, she claimed, Orchardson completed the whole painting in three days – just time enough to send it in for the exhibition. There may be some exaggeration in the story, but signs of sketchiness in one or two areas, especially in the background, indicate that the picture probably was finished in haste. The design, and to a slight degree the execution, do relate, as William Hardie has pointed out, to the work of James Drummond. Nevertheless, Orchardson's picture is far more 'painterly' in style than anything by Drummond – thin and trans-

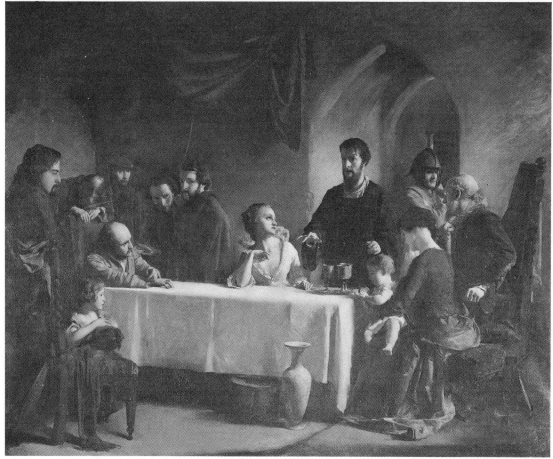

42

parent in the brown shadows, rather more solidly painted in the light areas, a tradition of execution that goes back to Wilkie. Wilkie's unfinished painting of *Knox dispensing the Sacrament*, which had been bought by the RSA in 1842, and was thus available to Orchardson for study was probably his most important compositional and stylistic source. The heads and hands in Wilkie's picture are extremely finely finished without any loss of painterly quality, or transparency in the shadows. Another painting, which may very likely have affected Orchardson, was Lauder's own *Christ teacheth humility* (catalogue no. 24), which is ordered in much the same way, the spectators being coherently massed in groups flanking the figure of Christ.

The subject of the *Wishart* is the first Protestant Sacrament in Scotland, administered by the Reformer at St Andrews, just before he was sent to the stake.

WILLIAM McTAGGART

43 Going to sea
Canvas : 84 × 71.5
Signed and dated : 1858
Lent by Kirkcaldy Art Gallery

In this very early picture the artist's interest in atmospheric effects is already clearly apparent. He seems to have painted it after seeing Millais' *Autumn Leaves* in the Manchester Art Treasures exhibition of 1857, also a dusk or twilight subject with children grouped in the extreme foreground, looking out wistfully towards the spectator. Half

lighting of this kind is rare in McTaggart's work, though the two dark *Dora* pictures (catalogue nos. 57 and 118) are other examples. Despite his inexperience at the time of painting *Going to sea* McTaggart has managed to keep suggestions of colour and luminosity in the shadows so that while the picture is very low in key it is never dense or muddy in effect. Orchardson's *Jeanie Deans* (catalogue no. 48) another twilight picture, provides an interesting contrast. Even at this early stage in their careers, McTaggart cared more about relating figures to their atmospheric environment, and Orchardson more about defining their shapes with a clear outline.

JOHN PETTIE

44 The Prison Pet
Canvas : 64 × 53
Lent by James Holloway

Like many of Pettie's subsequent works this is based on no definite literary source, though it is extremely reminiscent of the later part of Byron's poem *The Prisoner of Chillon*. Pettie's vignette of the solitary prisoner compelled by his loneliness to strike up a friendship with the rat that visits his cell is self explanatory. The picture was exhibited at the RSA in 1859, only the second year in which Pettie had shown pictures there, and he himself was described in the *Art Journal*'s review of the exhibition as 'a mere youth – but one who already paints with a dexterity, and thinks with a vigour far beyond his years'. The careful lighting on the stone blocks of the wall resembles Lauder's technique (catalogue no. 29), and the combination of this with the hunched immobile figure of the prisoner – rather too clearly painted directly from a paid model – show Pettie as still the talented student who had not emerged fully from his schooling or discovered his own abilities for movement and drama.

43

44

HUGH CAMERON

45 Going to the Hay *
Canvas : 57.2 × 42.5
Signed and dated: H. Cameron 1858–9
National Gallery of Scotland

When this was exhibited first at the RSA in 1859 *The Art Journal* reviewed it in terms of lavish praise: 'one of the best specimens of colour and legitimate artistic finish which has been exhibited in Edinburgh for years, and there were very few pictures exhibited last year in London superior to this . . . in the qualities named. The tone and texture, and simplicity of style achieved, is a high standard from which to make another start'. The wild rose hedge and open mouthed singing girl

45

recall Millais' *Ophelia* which was exhibited in Edinburgh in 1853. The more immediate prototype however was probably Millais' *The Blind Girl* shown at the RSA in 1858, the year Cameron began *Going to the Hay*. The motif of the butterfly is borrowed from Millais but Cameron's preference for muted pastel shades gives his own composition a sweeter and very different feel. *The Blind Girl* was also an influence on McTaggart's *Dora* and Herdman's *Rowan tree* (catalogue nos. 60 and 61).

ALEXANDER HOHENLOHE BURR

46 The night stall
Canvas : 52 × 47
Signed in monogram and dated: AHB '60
National Gallery of Scotland

This early work shows the meticulous care of draughtsmanship seen in the early paintings of all Lauder's pupils. The study of artificial light effects and cast shadows was evidently one of Burr's interests, for in the *Dora* of 1863 (catalogue no. 55) he moved on to tackle a more complex situation combining fire and daylight.

46

JOHN PETTIE

47 Cromwell's Saints *
Canvas : 42.5 × 52
Signed and dated: J. Pettie 62
National Gallery of Scotland

This was exhibited at the RSA in 1863. Although it was not intended specifically as an illustration to any Scott novel, it does seem likely that the idea was suggested to Pettie by the description of some of Cromwell's soldiers in their guardhouse at Windsor in Scott's *Woodstock*. 'By the fire sat two or three musketeers, listening to one who was expounding some religious mystery to them. He began half beneath his breath, but in tones of great volubility, which tones, as he approached the conclusion, became sharp and eager, as challenging either instant answer or silent acquiescence. The audience seemed to listen to the speaker with immovable features, only answering him with clouds of tobacco-smoke which they rolled from under their thick mustaches.' Scott's description of the Corporal's 'double height of steeple-crowned hat . . . and a treble proportion of sour gravity of aspect' would undoubtedly have appealed to Pettie who, possibly under the influence of Fettes Douglas' *Hudibras* (of 1856), was already showing a marked relish for picaresque historical situations. The straightforward country subjects of Chalmers and McTaggart seem not to have

appealed to him at all. He needed subject matter with a certain bite to it. The 'saint' in his picture with the pointed moustaches and pipe (right) is said to have been the artist Sam Bough, a sufficiently raffish character in his own right. *The Daily Review* for 18 February 1864 claimed that Pettie 'had somewhere picked up the notion that Cromwell's Saints were hypocrites, and he painted a group of scoundrels accordingly.'

The treatment of colour, especially on the breeches of the soldier to the right, is extremely elaborate, and suggests the influence of Lauder.

WILLIAM QUILLER ORCHARDSON

48 Jeanie Deans *
Canvas : 69.8 × 48.2
Private collection

Scott's heroine in his *Heart of Midlothian* was the simple and prosaic but resourceful and courageous Jeanie, who, to save her condemned sister, walked alone to London and pleaded for Effie's life with the Queen. Orchardson painted Jeanie equipped for her journey and barefooted, as was usual amongst eighteenth-century Scottish country girls. 'Her tartan screen served all the purposes of a riding habit, and of an umbrella; a small bundle contained such changes of linen as were absolutely necessary ... barefooted she proposed to perform her pilgrimage ... she was not aware that the English habits of *comfort* attach the idea of abject misery to the idea of a barefooted traveller.'

Exhibited at the RSA of 1863 *Jeanie Deans* was painted at much the same time as *Pettie's Cromwell's Saints* (catalogue no. 47), and Cameron's *Going to the Hay* (catalogue no. 45), and was followed by McTaggart's *Spring* of 1864 (catalogue no. 53). The very delicate and careful drawing of hands and feet are common to all four artists, and Orchardson is here working with the rustic, open-air subject matter of McTaggart rather than the sophisticated drawing room settings of his own later choice. Nevertheless one can see that Orchardson's twilight

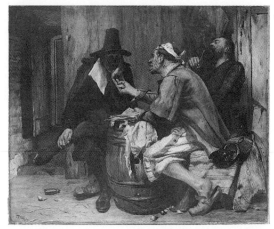

47

background of murky wood is used as a kind of decorative tapestry of muted and subtle colours suspended behind the figure of Jeanie, rather than being an open space inside which she stands. Orchardson had moved to London in 1862, and the difference in outlook between McTaggart who stayed in Scotland, and Orchardson, who moved south, is already beginning to emerge as the contrast between fidelity to visual experience, and a desire for beauty of line, colour and placement.

HUGH CAMERON

49 The Italian image seller
Canvas : 82.5 × 111
Signed: Hugh Cameron
Lent by Mr and Mrs Robert Nilsson

This painting, exhibited by Hugh Cameron at the RSA in 1862, shows an itinerant peddler of plaster statuettes – including a figure of the Virgin and a bust of Walter Scott – who has fallen asleep beside a stone dyke. The treatment of the landscape, and of the children, relates closely to contemporary work by McTaggart, e.g. *The past and the present* of 1860, *The old pathway* of 1861–62 and *The old pump well* (Smith Institute, Stirling) of 1862–63. Many years later, McTaggart himself painted two versions of a design showing an Italian image seller followed by a troop of children, under the title *Following the Fine Arts*.

THOMAS GRAHAM

50 The skipper's lad *
Canvas : 45.7 × 30.5
Signed and dated: T. Graham 1863
Lent by the Fine Art Society

Before the departure of Graham, Pettie, and Orchardson for London, Lauder's students were more homogeneous in tastes and interests than they became when their own mature personalities had developed fully in contrasting environments. Here Graham is painting the kind of child in the sort of

49

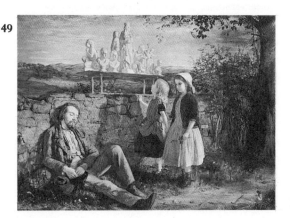

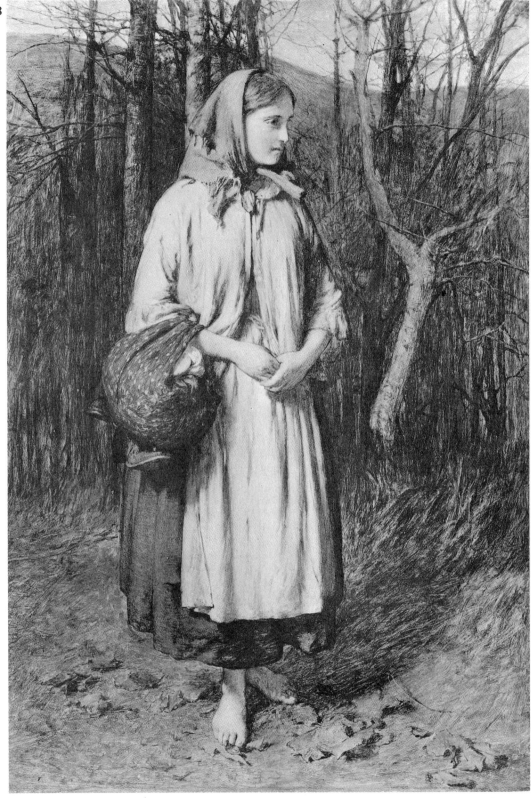

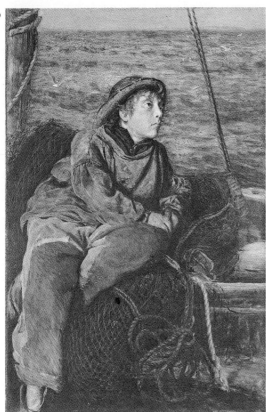

50

setting that one associates with McTaggart. However the atmospheric possibilities which would have attracted McTaggart were quite clearly not Graham's reason for choosing this subject, and his emphasis on linear draughtsmanship is like that of Orchardson and Pettie.

THOMAS GRAHAM

51 A young bohemian
Canvas : 90 × 63.2
Signed and dated: T. Graham / 64
National Gallery of Scotland

51

This is probably the picture shown by Graham at the British Institution in 1865. He was a more reticent artist than either Pettie or Orchardson, and his best pictures have a quiet charm, but lack the dash of Pettie, or the incisive drawing of Orchardson. The elaborate toning and glazing of the girl's skirt in this picture is akin to Pettie's painting technique in certain areas of *Cromwell's saints* (catalogue no. 47). The overall yellow and grey effect is one that critics noted in many of the early pictures of Lauder's pupils.

GEORGE PAUL CHALMERS

52 The tired devotee
Canvas (oval) : 25.7 × 22.5
Signed: G.P. Chalmers 1865
National Gallery of Scotland

52

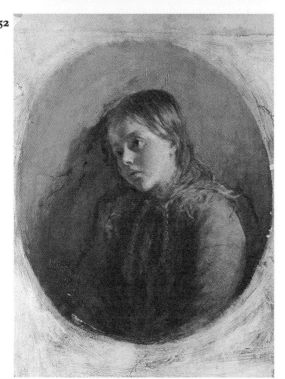

WILLIAM McTAGGART

53 Spring *
Canvas : 45.1 × 60.4
Signed in monogram and dated: WMT 1864
National Gallery of Scotland

When first painted this was one of a pair, its companion being *Autumn*, a harvest scene with an old lady knitting, two children, and a background of corn stooks and reapers.

The vivid green of the meadow was probably influenced by Pre-Raphaelite colour schemes, but in its purpose this is a very un-Pre-Raphaelite picture. McTaggart's lifelong preoccupation was with relating figures – usually children – atmospherically, physically, and emotionally to a piece of countryside, so that the viewer has the impression of complete unity of feeling. Here McTaggart's treatment of the shadows, falling for instance across the bare legs of the child lying down, show real observation of people as they appear in open sunlight, but even more effective is his use of separate touches of paint to break across the boundaries between figures, meadow, background and sky, suggesting that the same light envelopes them all and merges them together. This is particularly free and effective in the hazy blue green distance.

Such an innovative treatment was quite misunderstood by some contemporary critics who chided McTaggart for leaving his work unfinished. *The Daily Review* for 18 February 1864 found 'Mr McTaggart's greens are . . . kenspeckle . . . and withal somewhat crude and raw. The bank on which the children are playing . . . looks as if it wanted nothing but a little working on to be perfect, but it certainly does want that.'

GEORGE PAUL CHALMERS

54 Girl in a boat *
Canvas : 56 × 66.7
*Lent by the Trustees of the Orchar
Art Gallery*

The subject and strength of colour, are most unusual in Chalmers' work. The paintings by McTaggart which might appear most obviously to have influenced it were in fact produced afterwards. McTaggart's *Two boys and a dog in a boat* for example, was painted in about 1871 (catalogue no. 85) whereas Chalmers was working on his *Girl in a boat* in 1867 whilst staying on Arran with Mac-Whirter. The painting is, for the most part, very thin and sketchy, except in the head of the girl, which has been repeatedly worked over, with alterations to the position of the cheek and chin,

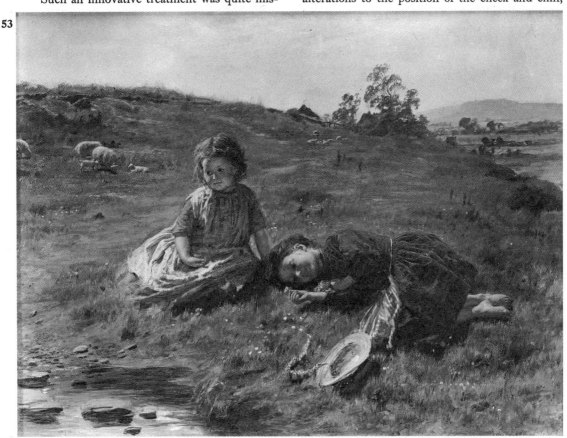
53

54

and has been carried to a fairly high degree of finish. The *contre jour* lighting, with the face in shadow against a background of strongly saturated colour was, however, a favourite effect of McTaggart's and can be seen for instance in the *Spring* of 1864 (catalogue no. 53).

ALEXANDER HOHENLOHE BURR

55 **Scene from 'Dora' ***
Canvas : 81.3 × 96.5
Signed: A. H. Burr
Lent by Perth Museum and Art Gallery

55

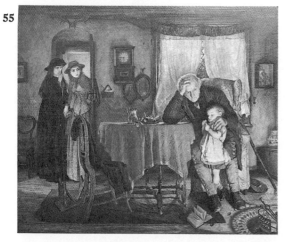

This painting, exhibited at the RSA in 1863 (250) was highly commended by the *Illustrated London News*. 'No painter hitherto comparatively little known has sent a work more remarkable, both for expression and execution, than the illustration of Tennyson's "Dora" by Mr A. H. Burr.' The poem describes how Dora effects a reconciliation between her uncle, a crusty tempered farmer, and his dead son's wife, by means of his small grandson. Subjects from *Dora* were painted by several of the Scott

Lauder group. A sketch by Orchardson of *Dora* was in an album belonging to MacWhirter, and McTaggart illustrated the poem in his Diploma picture (catalogue no. 60). Alexander Burr himself illustrated the poem again in 1868, producing what is virtually a companion in terms of subject to McTaggart's *Dora* of the same year (Sotheby's 22.2.72 (166) as *The Errant Daughter*). In his first *Dora*, Burr selected the moment when Dora and the widow discover the farmer playing with his grandson, and used it for an extremely well managed contrast between the dim interior and glowing fire of the cottage, and the brighter colder daylight outside. The traditional cottage interiors of Wilkie and Faed have here been given a new realism – probably influenced by Pre-Raphaelite painting.

HUGH CAMERON

56 **The gamekeeper ***
Canvas : 32 × 42.4
Signed and dated: H. Cameron / 1868
Lent by Aberdeen Art Gallery and Museums

56

WILLIAM McTAGGART

57 **Dora (twilight)**
Board: 19.7 × 15.3
Lent by the Trustees of Miss Barbra McTaggart

This is a sketch for the dark or evening version of McTaggart's diploma picture *Dora* (catalogue no. 60) and is now the only remaining guide to the original appearance of the picture.

JOHN BURR

58 **Love's young dream**
Canvas : 103.5 × 75.7
Signed: John Burr
Lent by the City of Dundee Art Gallery

The date of this picture is not known. It is probably a work of the 1860s, and has the vivid green of McTaggart's *Spring* (catalogue no. 53), together with the strongly emphasised linearity of Pettie and Orchardson.

the relationship of the two figures, their placing in the landscape, and the contrast between the mesh of stems and flowerheads in the foreground and the sweep of space into the far distance, show that McTaggart still retained a very clear memory image of Millais' *Blind Girl*, seen at the RSA in 1858. From the Millais he derived a format so valuable that it was in use until his life's end – a high viewpoint providing a high horizon, and foreground figures also seen from above, seated on the ground as if physically part of the great sweep of open space behind them. The paler colour, far greater emptiness in the landscape, and less abrupt transition between foreground and distance, together with the looser brushwork, are all un-Pre-Raphaelite elements in McTaggart's work that he developed later. *Dora* is a crucial picture, the germ in which lies latent most of McTaggart's subsequent work.

ALEXANDER HOHENLOHE BURR

59 Wild flowers
Canvas : 76.2 × 63.5
Signed : A. Burr
Lent by the City of Dundee Art Gallery

Like his brother's picture *Love's young dream* (catalogue no. 58), the date of this is not known. It is perhaps a work of the late 1860s or early 70s.

WILLIAM McTAGGART

60 Dora
Canvas : 118 × 97.8
Signed : W. McTaggart 1869
Lent by the Royal Scottish Academy

This was McTaggart's Diploma picture. It was shown in 1868 with a twilight effect, then partly repainted, and shown again in 1869 with its present sunlit appearance. Tennyson's poem *Dora* is a story of family estrangement and reconciliation. Dora attempts to make peace between her uncle and his son's widow Mary, whom he refuses to see, by bringing Mary's child into the field where he is harvesting. The first day she goes unnoticed until dusk, on the second her plan is successful and the old man is attracted by the sight of his little grandson. McTaggart's first version of the subject illustrated Dora's failure on the evening of her first day's wait. In the second version she has made, on her second morning, a floral decoration for the child's sunhat and a more hopeful mood prevails. Whereas in the twilit version *Dora* must have born a resemblance to Millais's *Autumn leaves*, in the sunlit one

ROBERT HERDMAN

61 The rowan tree *
Canvas : 101.6 × 76.2
Signed in monogram and dated : RH 1872
Inscribed on the reverse : R. Herdman
RSA / 1872
Private collection

Herdman exhibited this at the Glasgow Institute in 1873 (370), but he had already exhibited a picture of the same title at the RSA in 1867 (376). Possibly this is a replica of the earlier picture, but the exact relationship between them is not known. The model for the elder of the two girls is the same child, wearing the same striped jacket, who appears in *Evening thoughts* of 1864 (NGS), a fact which suggests that

61

this picture of 1872 must have been based on an earlier design. The Orchar collection contains a watercolour study for the picture, which may have an Arran setting. The influence of Millais' *Blind girl*, exhibited at the RSA in 1858 (89), is as apparent on Herdman's *Rowan tree* as on McTaggart's *Dora* (catalogue no. 60). Apart from such general features as the relationship between the older girl and young child, which both McTaggart and Herdman borrowed from Millais, they also adopted his method of painting the older girl's brown petticoat, by brushing the pigment horizontally across the folds of the skirt, rather than letting it follow the downward direction of the folds, as might have seemed more natural.

ROBERT HERDMAN

62 The artist's wife, Emma Catherine Abbott
Panel : 17.8 × 12.7
Private Collection

Herdman married Miss Abbott in 1857 and the portrait may have been painted in the late summer of that year.

ROBERT HERDMAN

63 Portrait of the artist's mother-in-law, Mrs Abbott
Canvas : 54.6 × 67.3
Signed and dated: R. Herdman 1862
Lent by Mrs M. Vaughan

Mrs Abbott came from Ireland and spent the last years of her life in Edinburgh.

63

62

GEORGE PAUL CHALMERS

64 Mrs May Torrie (or Chalmers, or Collie) the artist's mother (1810-79)
Canvas : 77 × 64
Lent by Angus District Museums

The careful and delicate style of this portrait, so very unlike the free handling normally associated with

Chalmers, together with the sitter's fairly youthful appearance, and the fashion of her hair, suggest a date about the early to mid 1850s, when Mrs Collie would have been in her mid forties. She was born May Torrie, married Mr Chalmers in 1832 then, after her husband's death in 1848, married Mr Collie. At the time the portrait was painted Chalmers may still have been a student of the Trustees' Academy. Certainly the thin, rather liquid washes of paint do resemble the student work of McTaggart.

64

WILLIAM QUILLER ORCHARDSON

65 Portrait of James Hall Cranstoun
Board : 38.4 × 27.3
Lent by Perth Museum and Art Gallery

James Hall Cranstoun (1821–1907) was a friend of Orchardson, at whose home in Perth the artist often stayed. The artist's wife saw some 'early' portraits of Cranstoun's brother and sister, and some student drawings by Orchardson, at James Cranstoun's house in 1906. This portrait is probably also fairly early, pre-dating the artist's move to London. There is a striking resemblance in style to some of Chalmers' portraits.

GEORGE PAUL CHALMERS

66 A Brittany chorister
Canvas : 30.5 × 25.4
Lent by the Stirling Smith Art Gallery and Museum

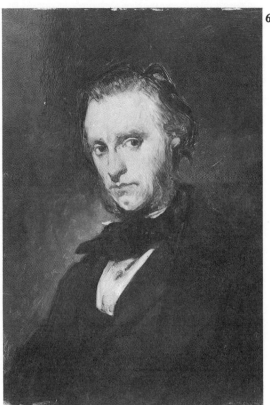

65

The artist went on a sketching trip to Brittany with Pettie and Tom Graham in 1862, and subsequently exhibited several paintings with Breton themes.

JOHN PETTIE

67 The Drumhead court martial *
Canvas : 69.5 × 104
Signed and dated: J. Pettie '65
Lent by Sheffield Art Galleries

Exhibited at the RA in 1865, this is one of the paintings by which Pettie clinched his success during his early years in London. He was made an Associate of the RA a year later. The *Illustrated London News* reviewed it as follows: 'Mr Pettie has, like Mr Orchardson, acquired a dexterity of handling which is a little too obtrusive. In the essentials, however, of character and telling a story, his Drum-head Court Martial (192) is a most remarkable work for an artist so newly risen into public notice. The prisoner on his trial is a captured Cavalier whom Roundhead troopers are roughly searching'. The story was Pettie's own invention – he was adept at inventing situations which, unlike those painted by all too many RA exhibitors, required no lengthy explanatory quotations in the catalogue. As with the earlier *Cromwell's Saints*, however, novels such as Scott's *Woodstock* probably provided the context out of which Pettie's ideas arose. His *Drumhead*

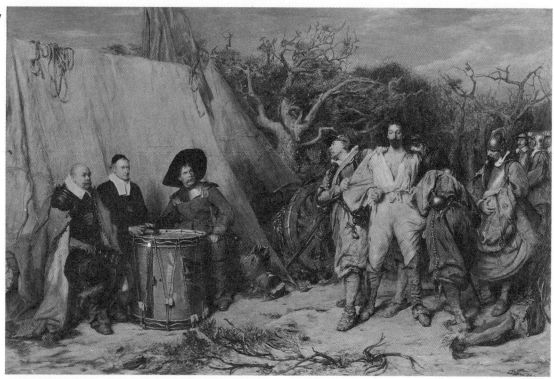

court martial is designed and grouped with Pettie's natural flair. His choice of episode, the apparently casual but in fact highly worked out organisation, clean and bright but harmonious colour scheme,

and very dextrous presentation of natural looking character and behaviour, together with his light hearted amorality, was in happy contrast to much English painting of the period, crowded in design, heavy handed in moral message, and stereotyped in character presentation.

ROBERT HERDMAN

68 Mary Queen of Scots' farewell to France
Canvas : 91.5 × 71
Signed in monogram and dated: 18 RH 67
Private Collection

Herdman had a stronger leaning towards the kind of romantic historical subject matter that attracted Lauder than had most of Lauder's other pupils with the possible exception of Pettie. Here the treatment of the rich dress fabrics and heavy brocaded drapery spilling across the planking of the deck is very close to Lauder in pictures such as the *Galeotti and Lewis XI* (catalogue no. 27). The subject matter sets Herdman apart from the other Lauder pupils who remained in Scotland, for Cameron, Chalmers and McTaggart at this date were all concerned with cottage, farm or fishing scenes.

GEORGE PAUL CHALMERS

69 Early sketch of the legend
Canvas : 36 × 53.5 (approx.)
Lent by the Trustees of the Orchar Art Gallery.

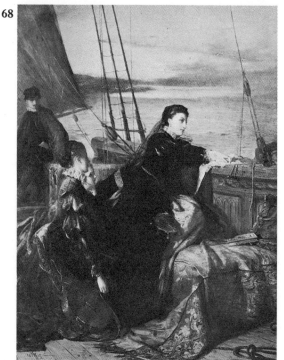

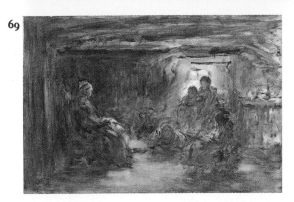

This is a rub in – probably all done at the same time – with only brown pigment and a few white highlights, and the white canvas priming is used to represent most of the light areas.

WILLIAM QUILLER ORCHARDSON

70 The story of a life
Canvas : 76.2 × 114.3
Lent by the Hon. Alan Clark MP

This was exhibited at the RA in 1866, the year before Chalmers and MacWhirter painted their collaborative picture of nuns (catalogue no. 71). The *Illustrated London News*' reviewer wrote: 'Mr Orchardson's workmanship has considerable resemblance to that of Mr Pettie; but he is "looser" in handling, and has more canvas "to let" (i.e. empty) . . . The eager, proselytising expression and gesture of the nun, and the varied effect her recital produces on the listeners, are well indicated; but

there is too great a family likeness among the novices.'

Orchardson himself may not have been aware that his composition in its basic essentials – an aged dark clad crone who relates a story with lifted hand to a circle of brightly lit and youthful listeners, clinging to each other, spellbound – was in fact exactly the composition of Chalmers' *Legend*, begun in 1864 (catalogue no. 78), but in reverse. Nothing better illustrates the contact and sympathy maintained between the artists who stayed in Scotland and those who went to London – in addition to the growing differences between their respective areas of subject matter – than the relationship and contrasts between Chalmers' *Legend* and Orchardson's *Story of a life*.

JOHN MacWHIRTER *and* GEORGE PAUL CHALMERS

71 The Convent Garden, San Miniato, Florence
Canvas : 63.5 × 95
Signed by both artists and dated 1867
Lent by James Holloway

This collaborative work, exhibited in 1868 at the RSA (566) was probably painted as a form of joint celebration by MacWhirter and Chalmers for their having been simultaneously elected Associates of the RSA in mid November 1867. Chalmers wrote from MacWhirter's studio in Mound Place, Edinburgh to tell his friend Simpson of Broughty Ferry the good news. The exhibition of 1868 was thus the first in which both men showed as Associates, and Chalmers was especially anxious to have a good and lavish display of work to justify the new honour. In

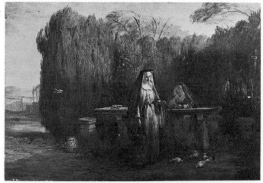

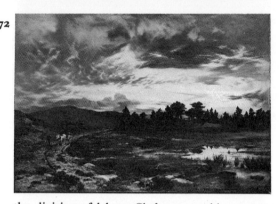

exhibited in 1867, presented something of an anti-climax, though from a painterly point of view it showed advances upon the previous picture. Reviewing it, the *Illustrated London News* expressed disappointment, but admired 'the slaty shadowed clouds, the deep purple hills, and the scattered pines which stand, black as mutes against the greenish sky. The general effect is almost wierdly sombre.' The colours of the sky relate the picture to the sunsets favoured by Robert Scott Lauder as backgrounds to some of his religious pictures but the forms of the various clouds are recorded with up to date Ruskinian accuracy. In choosing this type of melancholy, almost dispeopled, waterlogged landscape, with its pools, boulders and stunted or decaying vegetation, Graham showed considerable originality, preceding, and perhaps influencing Millais, who turned to such Scottish subjects in the 1870s, beginning with *Chill October* painted three years after *O'er Moor and Moss*.

MATURE PAINTINGS
BY LAUDER'S PUPILS

JOHN PETTIE

73 The Gambler's victim
Canvas : 70.8 × 92.1
Signed and dated: J. Pettie / 69
National Gallery of Scotland

This and the *Disgrace of Wolsey* (catalogue no. 74) were Pettie's exhibits at the 1869 RA exhibition. They are variants on the same basic compositional arrangement – later borrowed by Orchardson – by which the chief figure is brought forward, set to one side, and isolated from the others. Pettie claimed that he always began any picture by thinking up an almost abstract theme of colour and then proceeded to work it out in dramatic terms and build a story round it. Here his motif was perhaps the contrast between the daylight falling on the pallid face of the victimised boy and the murky lamplit background of the gambling hell. With Lauder's pupils the

the division of labour Chalmers would appear to have painted the figures, and MacWhirter, who had travelled in Italy, the landscape background. Monks and nuns held a peculiar fascination for members of the Lauder group, and Orchardson's *Story of a Life* (catalogue no. 70), had been exhibited at the RA in 1866 the year preceding *The Convent Garden*. Collaborations were also common between other members of the Lauder group. In 1860 MacWhirter and Orchardson combined on a picture. MacWhirter and Pettie collaborated on at least two pictures, and after Chalmers' death Pettie touched or completed several of his friend's unfinished works. Such activities indicate close bonds of sympathy and a basis of shared artistic values amongst Lauder's students.

PETER GRAHAM

**72 O'er moor and moss. 'When in the
crimson cloud of eve the lingering
light decays' ***
Canvas : 110.8 × 164.2
Signed and dated: Peter Graham 1867
National Gallery of Scotland

The first landscape exhibited by Peter Graham at the RA of 1866, *A spate in the Highlands*, was a melodrama so astounding in effect that it was almost impossible for the artist to follow it up with anything of equivalent impact. To the viewer who expected another simple shock, *O'er moor and moss*,

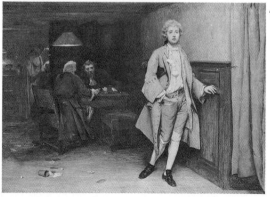
73

illustrative necessities were never allowed to dominate pictorial arrangements. Painterly qualities invariably came foremost. Nevertheless, it was Pettie's gift that he could invest every element with a double meaning. The pieces of still life, such as the fallen cards, the boy's dishevelled clothes and the lamp behind, illuminating the other gamesters assembling their winnings, are conceived by Pettie primarily as opportunities for fine painting and yet each one has a considered and definite purpose in explaining that it is dawn, that the young man has been gambling all night, and has been cheated by some experienced card sharpers out of most of his property. Despite anachronisms such as the nineteenth century lampshade, the date intended by Pettie seems to have been circa 1745. He had probably been looking at paintings and prints by Hogarth, but his picture is no pastiche. The care and precision with which the boy's coat, breeches and shirt are painted suggest that Pettie was working from genuine examples.

JOHN PETTIE

74 The disgrace of Cardinal Wolsey
Canvas: 99.7 × 153.7
Signed and dated: J. Pettie 1869
Lent by Sheffield City Art Galleries

74

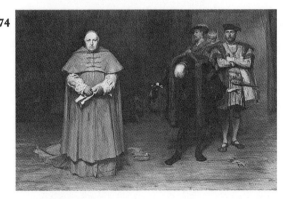

This was exhibited at the RA in 1869, the same year in which Pettie showed *The gambler's victim* (catalogue no. 73). The *Art Journal* claimed 'we have seldom seen so striking or true an analysis of character. We seem to read the history of a life, the summary of a career, in that crafty face.' Pettie chose the moment of Wolsey's downfall as given by Shakespeare in *King Henry the eighth*, Act 3, Scene 2. The Cardinal has just been handed back two of his own, self incriminating letters, by the King. In the background hover the hostile Dukes of Norfolk and Suffolk and the Earl of Surrey, who have come to demand the rendering up of the great seal. In this dramatic composition Pettie explored what was to be Orchardson's later theme in the two scenes of Napoleon in defeat (catalogue no. 108). At points like these the work of these two artists seems very

close. The vivid and glowing effect of the cardinal's cape seems to have been achieved by Pettie not with the application of solid red paint – as in the *Drumhead Court Martial* – which might have looked dead over a large area, but by glazing translucent red pigment over a white and grey monochromatic underpainting. The brilliance of the colour is in its own way a mocking commentary on Wolsey's overthrow.

WILLIAM QUILLER ORCHARDSON

75 Casus belli: a scene from 'Peveril of the Peak'
Canvas: 77.5 × 111.8
Signed: W. Q. Orchardson
Lent by Glasgow Art Gallery and Museum

Orchardson's painting exhibited at the RA in 1872 is typical of the yellowish and greenish tinged greys, and broken, scratchy handling that his critics – accustomed to the stronger colours and higher finish of English painting in the 1850s – so frequently complained about. The motif is taken from Scott's Restoration novel *Peveril of the Peak*, from which Lauder at an earlier date, and Pettie later (catalogue no. 106), also took subjects. The hero Julian is shown as the unwilling escort of two ladies – rivals for his love – followed by two bravos in the pay of the Duke of Buckingham, who jeer at Peveril in the hopes of forcing a quarrel on to him. The painting is an excellent example of Orchardson's use of outline and simplified silhouette to express the essentials of character and situation. It was a draughtsman's technique that he employed with increasing mastery, and which culminates in such pictures as the *Napoleon at St Helena* (catalogue no. 108) or the unfinished *Last dance* (catalogue no. 122). Initially Orchardson may have profited by the example of Lauder in the 1850s. Lauder's *Gow Chrom* for instance (catalogue no. 29) exploits contrasting silhouettes in a similar way, so as to express the characters and relationship between the Perth armourer and his shrinking companion.

WILLIAM QUILLER ORCHARDSON

76 The queen of the swords *
Canvas: 47.3 × 80.6
Signed: W. Q. Orchardson
National Gallery of Scotland

The scene depicted is a free rendering of Scott's description of the Shetland sword dance in his novel *The Pirate*. The 'queen' is his heroine, Minna Troil, whose courageous character is exemplified by her bold reactions to the arch of sword blades from which her friends shrink in alarm.

This is a study of circa 1876–77 for the slightly larger painting exhibited at the RA in 1877 (Forbes

Magazine collection). Not only is it the last of Orchardson's illustrations to Scott, but also the last of his paintings to have any Scottish subject matter or context. It is, of all Orchardson's works, that which shows most strongly the influence of Wilkie, and in particular of *Blind man's buff*, and *The penny wedding*, both of which were probably examined by Orchardson whilst they were on loan to the London International Exhibition of 1874.

JOHN PETTIE

77 Hunted Down *
Canvas : 76 × 48
Lent by the Patrick Allan-Fraser of Hospitalfield Trust, Arbroath

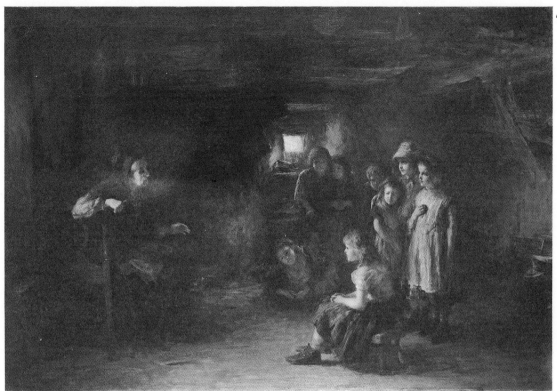

Possibly this is the picture exhibited at the Royal Academy in 1877 but another version was formerly in Bristol City Art Gallery. The composition is one of a number by Pettie, produced in the later 1870s, illustrating clan warfare or the Jacobite uprisings in the Highlands. Others are *Disbanded* 1877, *A moment of danger* 1878 and *The Highland outpost* 1878. In these Pettie seems to have been attracted by the visual image of a lone warrior with tartan and claymore, but to have been unconcerned about precise details of time and place. The pictures do not therefore relate to any specific events either in history or works of fiction. J. B. Macdonald, a minor artist who was also one of Lauder's pupils, had produced compositions with the titles *Out in the '45* and *We kenned his hiding in the glen*, and these may have influenced Pettie. Pettie's biographer Martin Hardie believed that at this time he was re-reading the novels of Scott.

GEORGE PAUL CHALMERS

78 The Legend *
Canvas : 102.9 × 154.3
National Gallery of Scotland

The legend is unfinished. It was begun by Chalmers in 1864, and its progress is charted in the letters he wrote to his friend Simpson of Broughty Ferry. The initial idea seems to have arisen out of a design on which Chalmers was working (now lost), show-ing the two sisters, Minna and Brenda, from Scott's *Pirate*, listening to the seer Norna. A study for this is illustrated as *The legend* in the catalogue of A. F. Stewart's collection of paintings (privately printed 1920).

The Orchar study for *The legend* (catalogue no. 69) shows that Chalmers originally envisaged a fairly simple scheme with the back lighting that also appears in McTaggart's *Spring* of 1864, but during the course of his work the lighting effects became increasingly complex. As with all of his compositions that Chalmers took most seriously, the finishing of *The legend* cost him agonies. On more than one occasion his friends saw it, as they thought, virtually complete, only to return later and find it had been scraped out. 'Just yesterday', Chalmers wrote on 1 January 1865, 'I changed the *whole* effect of the picture – the general effect is much finer, but it is at the sacrifice of a month's work – . . . I have been waiting and working thinking it would come, the more work I put on it, the worse it became – until I got into complete despair and yesterday smashed into it and made it a thousand times more simple'. By the end of the month he had abandoned it. In August he had taken it up again. 'I have been labouring at "The Legend" very hard, and found that the composition was so bad that it positively would not come – in fact it would not finish – I have therefore *scraped the half of it out –*' In '66 and '67 he mentioned the possibility of

finishing it if he could only be in a sufficiently calm and collected frame of mind. Thereafter we hear nothing further, but he is supposed to have resumed work on it towards the end of his life. As it stands now *The legend* is complete on the left side and in the figure of the old woman. The group of children has been subjected to one of Chalmers' drastic reworkings, as can be seen in the slashes of paint over the frock of the child on the right.

When *The legend* was begun it would probably have formed a dark brown interior version of McTaggart's green outdoor scenes with children. After 1870 Chalmers was familiar with the work of the Hague painter Israels, artist of sombre and poverty-struck cottage interiors. Some of his changes seem to have pushed *The legend* much nearer to the scenes depicted by Israels. However, the austerity and grimness of peasant life – Israel's theme – was not the concern of Chalmers. Rather it was the mystery of colour in the smoky atmosphere, and the old woman's power of spell-binding her listeners that attracted him.

HUGH CAMERON

79 A lonely life *
Canvas : 84.5 × 63.5
Signed: Hugh Cameron
National Gallery of Scotland

In the 1870s Cameron produced a number of paintings showing Scottish country people engaged on hard farm tasks, or collecting and dragging firewood. The designs of some of these suggest the influence of the French painter Millet's scenes of peasant life. *A lonely life* was first exhibited in 1873. It has the free, streaky handling and low colour key that one associates with Chalmers, and was in fact painted for John McGavin of Glasgow who was a friend of Chalmers and owned several of the latter's paintings. McGavin was also a collector of Corot, Diaz, Israels, Maris, and Millet and one must assume that he saw Cameron as an adherent to the same branch of painting as these.

GEORGE PAUL CHALMERS

80 The evening of life
Canvas : 63 × 54.5
Signed: G. P. Chalmers
Lent by the Trustees of the Orchar Art Gallery

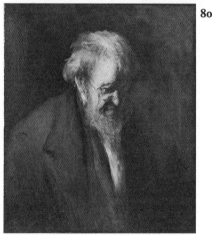

Before recent re-lining this was inscribed on the reverse below the stretcher, in Pettie's hand: Painted by G.P. Chalmers / worked upon by J. Pettie / 1878. Since 1878 was the year of Chalmers' tragic death, it is clear that the painting must have been found nearly finished in his studio, sufficiently completed probably, for a very little work on it by Pettie to bring it into a fit condition to be sold, and thus be of financial assistance to Chalmers' mother.

Pettie was extremely fond of Chalmers and would have carried out the task of completion on this and other pictures as a last act of friendship. 'I wish I were a girl that I might cry my eyes out to try and relieve this horrid weight on my heart' Pettie wrote to McTaggart after Chalmers' murder, 'they cannot do poor Geordie too much honour. . . . You and I will keep his memory green for many a year yet.' In all essentials the painting is the conception and work of Chalmers, with the breadth of execution and luminous, subtly coloured greys that he valued, but often destroyed or lost in the anxieties and agonies that finishing his pictures always cost him.

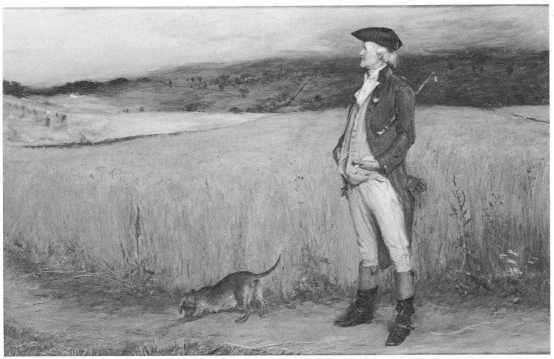

JOHN PETTIE

81 The laird *
Canvas : 64 × 98.3
Signed : J. Pettie
*Lent by the Trustees of the Orchar
Art Gallery*

This was exhibited at the RA of 1878. Pettie had
passed a holiday at Dundee and then at Callander
the previous summer. The contemplative, un-
dramatic mood, and the emphasis on the landscape
aspect are both uncharacteristic of Pettie, though
the sense of pride of possession conveyed by the
laird's stance, and expressed in every line of his
figure, is more typical. The treatment of the corn-
field bears a strong resemblance to that in McTag-
gart's *Dora* of 1869 (catalogue no. 60), and the
landscape beyond the field is not unlike some of
Chalmers' work.

HUGH CAMERON

82 Gleaners returning *
Canvas : 35 × 47
Signed : Hugh Cameron 1881
*Lent by the Trustees of the Orchar
Art Gallery*

This was painted while Hugh Cameron was living
in London. He was a more timid and unadventurous
artist than either McTaggart or Chalmers, and his
Gleaners is a sweetened and softened version of
Millet's Barbizon subjects, painted in the streaky
technique associated with most of Lauder's pupils.

JOHN BURR

83 A happy home *
Panel : 33 × 22.5
Signed : J.Burr
Lent by Aberdeen Art Gallery and Museums

83
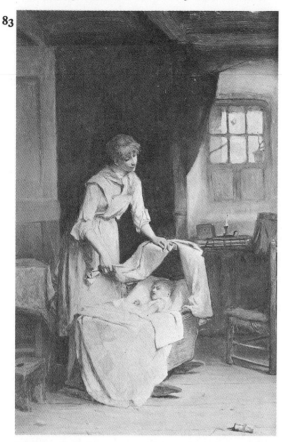

This is probably a work of the 1870s or 80s. John
Burr's taste for pastel colours, especially soft pinks,
and for a clearly marked, telling outline, remind one
of Orchardson, but unlike Orchardson he adhered
to cottage – rather than drawing room – subject
matter.

WILLIAM McTAGGART

84 On the white sands *
Canvas : 43.5 × 57
*Lent by the Trustees of the Orchar
Art Gallery*

This is inscribed on a fairly recent label on the
reverse: At – Bayvoich. Machrihanish. Mull of
Kintyre, Argyll. Caw dates it to 1870 but it was not
exhibited at the RSA until 1872. In it McTaggart's
interest in *contre jour* lighting as seen in *Spring*
(catalogue no. 53) is maintained, but the treatment
of shadow is far broader and bolder with the whole
figure of the small girl thrown under the blue cast

shadow of the rocks. The observation of cast
shadows, their exact contours and colours, seems
also to have been a subject of interest to A. H. Burr,
and Hugh Cameron during the 1860s. The silvery
colouring is particularly beautiful.

WILLIAM McTAGGART

85 Two boys and a dog in a boat
Canvas : 36.5 × 54.2
Signed: W.McTaggart
*Lent by the Trustees of the Orchar
Art Gallery*

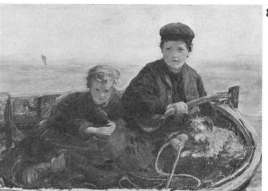
85

This was painted in about 1871. Compared with
The young fishers of five years later (catalogue
no. 88) it is bolder in composition, more brilliant
in colour, and flatter in the treatment of light and
shadow, especially across the boys' faces. Close
examination of the surface shows that McTaggart
must have worked out his composition as he went
along. There are signs of several changes, and the
small dog was added in on top of the shadowed
planking of the boat.

WILLIAM QUILLER
ORCHARDSON

86 Toilers of the sea *
Canvas : 89.5 × 145
Lent by Aberdeen Art Gallery and Museums

As a boy of fifteen or sixteen Orchardson spent a
holiday in Arbroath. There he struck up a friend-
ship with an old fisherman whom he accompanied
every day on expeditions after mackerel. His paint-
ing of 1870 is thus informed by real knowledge and
experience of sailing and fishing. By a piece of
imaginative and inventive diagonal placing, and
the cropping of the boat by the top and left canvas
edges, Orchardson has implied the spectator's
presence in another boat alongside. It is perhaps the
most McTaggart-like subject he ever tackled, but
the conception, which depends entirely on draughts-
manship – even the surfaces of the waves are drawn

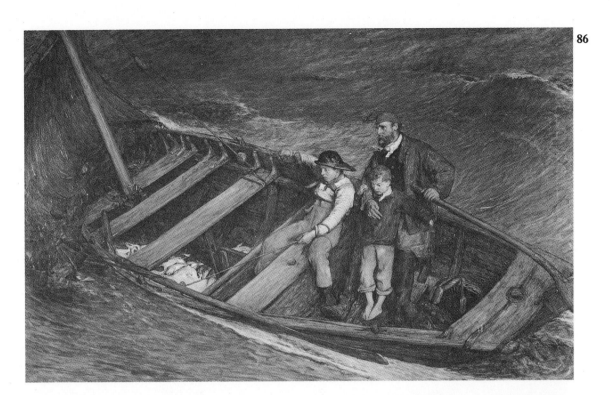

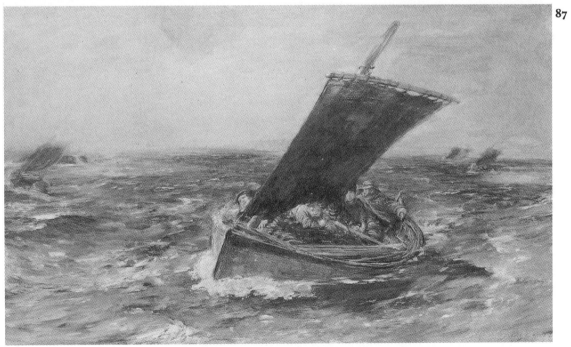

with paint – is totally unlike McTaggart's approach to fishing scenes.

The subject of the hardships or labours of the poor in modern life was not really of a nature to appeal to Orchardson, and his *Toilers of the sea* is an isolated specimen of this genre.

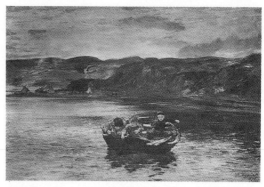
88

WILLIAM McTAGGART

87 Through wind and rain
Canvas : 85 × 141.2
Signed and dated: W. McTaggart 1875
Lent by the Trustees of the Orchar
Art Gallery

Although the frame bears a plaque inscribed *Through Mist and rain*, the above was the original title of this work, when it was exhibited at the RSA in 1875. *The Art Journal* described it as 'all verve and motion – a fishing boat scudding in mad haste before the breeze in an ocean swell'. The patent sketchiness of the painting seems in the main to have been accepted by critics as a suitable conveyance for the speed and atmosphere of the subject.

WILLIAM McTAGGART

88 The young fishers
Canvas : 72.4 × 108
Signed and dated: W. McTaggart 1876
National Gallery of Scotland

This was begun at Kilkerran, Ayrshire, in 1874, completed and exhibited in 1876. A comparison of this with catalogue no. 87, finished in the preceding year, shows that McTaggart's development cannot be explained as a straightforward stylistic progression from a tight and detailed to a broad and

sketchy manner, for the 1875 picture is far more sketchy than the 1876 one, and neither seems to have anything in common with the earlier boating scene of circa 1871 (catalogue no. 85). Now, as later in his life, McTaggart's technique was related almost entirely to the predominant character of his subject.

GEORGE PAUL CHALMERS

89 Gathering water lilies
Canvas : 29.2 × 50.8
Lent by the Fine Art Society

This is illustrated in Pinnington's biography of Chalmers. It was probably painted in the 1870s and forms an interesting contrast to McTaggart's *Young fishers* of 1876 (catalogue no. 88). It is possible that Chalmers' *Lilies*, like McTaggart's *Wave* (catalogue no. 92), was painted under the influence of some of Whistler's *Nocturnes*. The simplicity of these, their tonal unity and elimination of inessential detail would probably have appealed to Chalmers.

89

(88)

GEORGE PAUL CHALMERS

90 Loch Lee
Paper mounted on canvas (?) : 26.6 × 36.5
Signed and inscribed : G. P. Chalmers /
Lochlee
*Lent by the Trustees of the Orchar
Art Gallery*

Unlike McTaggart, Chalmers was primarily a
painter of figures with a taste for the controlled or
dim lighting of interiors. He turned to landscape
relatively late, and on the whole his landscapes are
subdued in colour and low in tone, showing his taste
for the misty or sombre effects of the French artists
Daubigny and Corot. Unlike MacWhirter and Peter
Graham he chose landscapes for slight and passing
effects of atmosphere, not for dramatic scenic
features.

GEORGE PAUL CHALMERS

91 The head of Loch Lomond
Canvas : 30 × 45
Signed : G. P. Chalmers
*Lent by the Trustees of the Orchar
Art Gallery*

This shows Chalmers' use of contrasted translucent
and opaque pigment, of sharply outlined or
smudged form, greys composed with touches of
pink, blue, and green, and great variety of brush-
work. In his smaller pictures and landscapes
Chalmers was seldom tempted to the alterations

91

of mind and overworking that caused such disaster
to some of his major pictures. In the small pictures
his concept of finish seems to have been a matter of
stopping when the colour harmony and rhythm
necessary for the idea had been carried out, so that
spontaneity of perception and brushwork was
maintained to the end.

WILLIAM McTAGGART

92 The wave *
Canvas : 62 × 92
Signed and dated : W. McTaggart 1881
Lent by Kirkcaldy Art Gallery

The smoothly flowing, liquid paint, laid down in
long horizontal strokes, suggests that McTaggart
had admired the technique used by Whistler in some
of his sea and river *Nocturnes*. For McTaggart this

92

(89)

simple and broad treatment was a useful counter-balance to the much smaller and more broken-up brushstrokes he had used in earlier pictures such as *The young fishers* (catalogue no. 88). The complete absence of human beings in the scene was found disconcerting by at least one contemporary reviewer.

THOMAS GRAHAM

93 Old Houses
Canvas : 25 × 32.5
Signed : T. Graham
Inscribed on a label on the reverse: Old Houses / Exhibited Royal Academy 1877 / T. Graham / Stanhope Yard / Delancey St.
Lent by Kirkcaldy Art Gallery

93

94

PETER GRAHAM

94 Wandering shadows
Canvas : 134.5 × 183
Signed and dated: Peter Graham 1878
National Gallery of Scotland

When this was exhibited at the RA in 1878 its 'life and movement' were admired by *The Art Journal*. 'The real and all-engrossing feature of the scene is the rising rocky hillside, across whose face the cloud shadows sweep grandly and swiftly. So palpable is their motion, that the visitor tarries before the picture to watch them chase each other.' Graham himself had written to a friend in 1870, 'When I came to study clouds and skies, I recognised the enchantment of effect to be caused by the same old laws of light and shade I had tried to get acquainted with at the Academy (i.e. the Trustees' Academy).' There were many similarities between the paintings of Peter Graham and MacWhirter, each of whom were purveyors of images of romantic Scotland, and especially the Highlands.

JOHN MacWHIRTER

95 The Lady of the Woods *
Canvas : 152.7 × 105
Lent by City of Manchester Art Galleries

This was exhibited at the Royal Academy in 1876 and was illustrated in *The Art Journal* in 1879 where it was described as 'a graceful birch-tree . . . rearing her tender branches laden with golden leaves against the blue sky: all the background is painted in beautiful harmony and keeping – a delicious scene most suggestive of quietude and repose, with all its details most conscientiously represented'. MacWhirter had a great love for trees and became renowned for his treatment of them. He usually gave his tree subjects titles implying the possession of a human personality. In contrast to McTaggart

95

whose painting of an autumnal birch is broad and sketchy (catalogue no. 112) MacWhirter always preserved his early taste for Pre-Raphaelite detail – Ruskin had formed a collection of his early flower studies – but managed to combine this precision with a sense of atmosphere and space.

GEORGE PAUL CHALMERS

96 Portrait of John Hutchison
Canvas : 22.7 × 17.8
Scottish National Portrait Gallery

John Hutchison was one of Lauder's pupils, and later carved the marble head for Lauder's tomb in Warriston cemetery (see catalogue no. 124).

GEORGE PAUL CHALMERS

97 The artist's mother *
Panel : 30.5 × 24.2
Lent by Glasgow Art Gallery and Museum

This was illustrated in Pinnington's monograph on Chalmers. Its date is not known but it must be a fairly late work.

97

GEORGE PAUL CHALMERS

98 Aitchie *
Canvas: 60.5 × 39
Signed: G.P. Chalmers
Lent by Aberdeen Art Gallery and Museums

The sitter was Rachel Evelyn White the daughter of
Chalmers' friend John Forbes White of Aberdeen.
Chalmers was working on portraits of both father
and daughter in January 1874 and *Aitchie* was
exhibited at the R S A in the same year. It is one of the
most successful of the portraits which the artist
brought to a high state of completion.

98

JOHN PETTIE

**99 A knight of the 17th century: Portrait of
William Black**
Canvas: 129.6 × 81.5
Signed and dated: J.Pettie 1877
Lent by Glasgow Art Gallery and Museum

William Black (1841–98) was a Scottish novelist
who had moved from Glasgow to London in 1864
about two years after Pettie's own move. Pettie's
presentation of his sitter in complete armour is an
imposition of his own exuberantly romantic
temperament rather than a genuine means of
expressing the character of William Black. This
flamboyant portrait is a distinct contrast to the
reserved but subtle portraiture produced by
Orchardson in the 1880s and 90s.

WILLIAM McTAGGART

100 Mrs W.L.Brown and her three daughters
Canvas: 135.2 × 115
Private Collection

This was originally a larger picture – Caw gives the
dimensions as 57 × 78 inches, i.e. 144.7 × 198.1 cm –
and was signed and dated bottom right: W. McTag-
gart 1885. This right-hand portion, which also
contained the figure of Mrs Brown's son, was later
cut off by the owner. A small watercolour replica
made by the artist (private collection) shows
the original proportions and grouping. Though
primarily, in his mature years, a landscape painter,
McTaggart continued to produce occasional
portraits, being especially successful with children.
This group of mother and children provides an
interesting contrast to the almost contemporary
Orchardson, *Master Baby* (catalogue no. 101),
emphasising the, by now, divergent approaches of
these two artists. McTaggart provides suggestions
of a spacious open air setting whereas Orchardson
places his sitters in a drawing room with hints of a
flat rear wall. Paradoxically, although McTaggart's
sitters are lined up and posed, fully aware of the
artist's presence in front of them, and Orchardson's
mother and child are totally absorbed within their
private game, it is Orchardson's painting that most
conveys an atmosphere of conscious artifice and

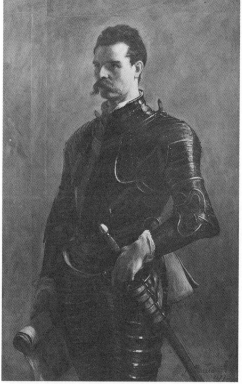

99

the control of elegant taste, whereas McTaggart's appears curiously innocent and spontaneous, like a family snapshot. Arrangement in the sense of aesthetic surface design held little interest for McTaggart.

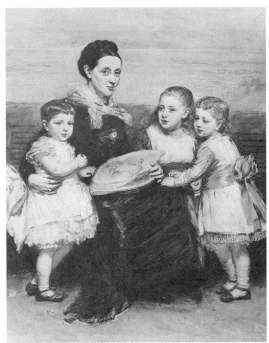

WILLIAM QUILLER ORCHARDSON

101 Master Baby
Canvas : 108 × 166
Signed and dated: WQO / 86
National Gallery of Scotland

This is a portrait of the artist's wife and son Gordon. It was based on a real incident, but the existence of several preparatory drawings, for the mother and child (NGS), for the cane work of the settee (NGS), and for the baby (private collection), show how much thought and calculation the artist put into his arrangement. The design – but not the handling – is somewhat reminiscent of certain French portraits, and in particular, certain portraits by Manet that Orchardson could hardly have known. Very possibly the French influence had reached him via Whistler whose *At the piano* is constructed with silhouette shapes, carefully related and ingeniously cut by the edge of the picture. Not surprisingly, Orchardson's picture was liked by Degas, Sickert, and George Moore – the two last-named being both admirers of contemporary French art.

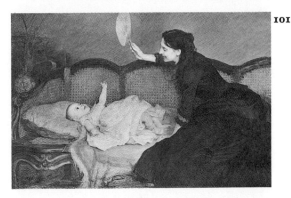

LATE PAINTINGS
BY LAUDER'S PUPILS

JOHN PETTIE

102 Portrait of James Campbell Noble
Canvas : 82 × 64.5
Signed and dated: J. Pettie 1889
Scottish National Portrait Gallery

Campbell Noble (1846–1913) was initially a figure painter who turned to landscape. This portrait was painted while both artists were on holiday in Berwickshire, in a studio made by Noble out of two old cottages. Pettie greatly admired the warm Remembrandt-like atmosphere produced by the roof light of the 'studio'. His portrait of Noble was first modelled with a monochromatic underpainting and then glazed with colour, the main pigments used being – besides white – yellow ochre, raw siena, light red, Indian red, rose madder, raw umber, permanent blue, terra verte and ebony black. The portrait took seven days to complete, and the brilliantly lit edge of the palette was added on the last day.

It is interesting to compare Pettie's technique with that of McTaggart in his self portrait holding a palette (catalogue no. 103), painted only three years

later. The impression left by the Pettie is intentionally 'old masterish', reminiscent of the chiaroscuro of Titian and Rembrandt, an effect achieved by a traditional build up of the surface in stages. The McTaggart is far more casual, painted directly, without the pre-meditation required by glazing, and with a fair amount of bare canvas left.

WILLIAM McTAGGART

103 Self-portrait: Oak leaves in Autumn *
Canvas : 83.8 × 71.1
Signed on the palette: W. McTaggart 1892
National Gallery of Scotland

This was exhibited at the RSA in 1893 (237) as *Oak leaves in Autumn*. It hung over the fireplace of the artist's dining room at Broomieknowe during his lifetime, and remained there until the sale of the house, when it was presented by his own wish, to

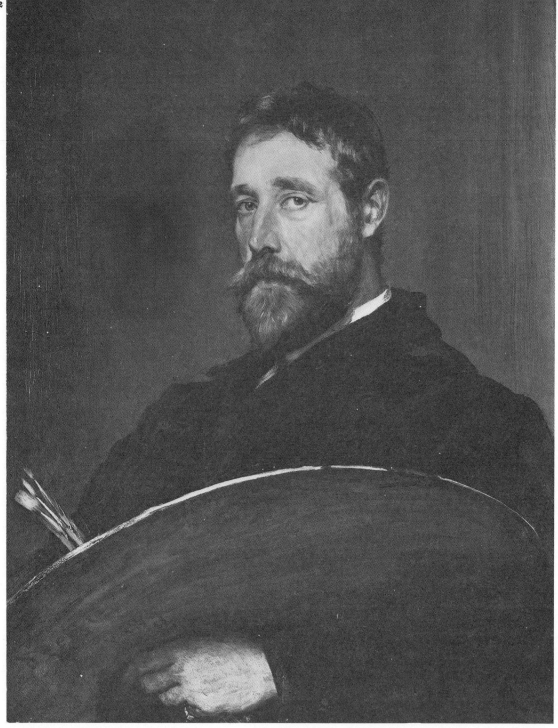

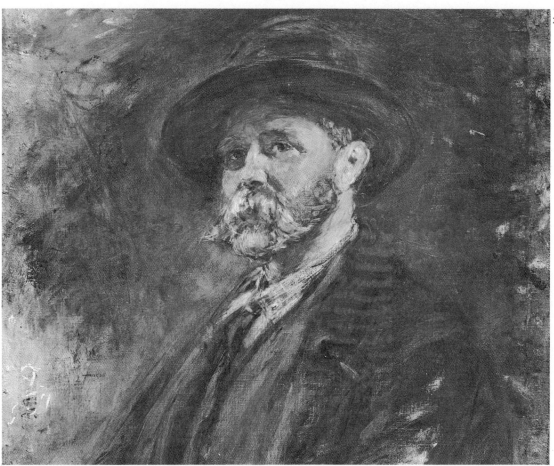

the National Gallery of Scotland. The free, lively handling is rather like that of Chalmers in some of his smaller portraits. As the portrayal of an artist it makes an interesting contrast to Pettie's portrait of Campbell Noble (catalogue no. 102) in which the silhouette of the palette provides the main dramatic point.

than the elegantly bred and enigmatic personages of Orchardson, and Pettie seems not to have shared Orchardson's enchantment with the interior decor that composes the refined atmosphere surrounding the latter's *The rivals* (catalogue no. 105). In other respects the theme of the girl flirting with more than one admirer is the same in both pictures.

JOHN PETTIE

104 Two strings to her bow *
Canvas : 84 × 120.8
Signed: J. Pettie
Lent by Glasgow Art Gallery and Museum

Occasionally Pettie and Orchardson seem to be trespassing on each other's ground. This picture exhibited at the RA in 1887, is an example of Pettie employing a theme and period normally associated with Orchardson. The 1880s, during which the illustrated books of Caldecott and Kate Greenaway, were appearing, saw a revival of taste for the dress fashions, furnishings and delicate colours of the Recency period, which affected both Pettie and Orchardson. Pettie's historical characters behave in a more blatant and lively – not to say vulgar – way

WILLIAM QUILLER ORCHARDSON

105 The rivals *
Canvas : 84 × 117
Signed and dated: WQO / 95
National Gallery of Scotland

This picture, exhibited in 1897, is one of the latest and most sophisticated of the artist's Recency or Empire scenes. His interest in this period coincided with the appearance of the illustrated children's books of Caldecott and Kate Greenaway, with their pale bright colours, clear outlines and telling simplicity of design. During the 1880s and 90s these period scenes alternated with contemporary ones in Orchardson's pictures, and apart from the differences of costume he seems to have made no distinc-

104

105

room hung with stamped Spanish leather, when a panel in the wall slides open to reveal an unknown lady dressed in mourning. This sinister person, whom the children at first assume to be a ghost, is in fact the Countess of Derby, a fugitive Royalist who has concealed herself in a secret room. It was typical of Pettie to have selected unerringly the most visually dramatic moment in the early part of the book, but having done so, the anecdotal side was of little further interest to him, becoming simply the pretext for a scintillating colour scheme of blue and gold, and a bravura display of dashing paint work. This type of subject is a revival of the kind of themes and situations – derived initially from Lauder and Fettes Douglas – which had interested Pettie and Orchardson in the 1860s and 70s – old period rooms, old tapestry or decorated hangings, and an atmosphere of conspiracy and concealment. The costume and pose of the Countess of Derby, and the toy spaniel, suggest a memory of Van Dyck's *Lomellini family* with which Pettie would have been familiar as a student.

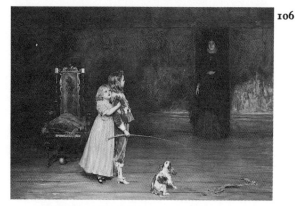

106

tion between the two types of work, his own drawing rooms and furniture generally serving as the settings for both. His subjects, in the historical pieces, were of the slightest and most indefinite nature, concerned with the intricacies and minor qualms or puzzles of human relationships within the rules of a highly civilized and polite society. The viewer is guided through the picture by the ingenious placing of furniture and tonal or colour accents, but is never told clearly what the artist thinks about it all. By contrast Orchardson's bevy of imitators followed him with ballroom and courtship scenes of the Regency in which frills and sentiment are highly prominent and quality of design and execution almost nowhere.

JOHN PETTIE

106 Scene from 'Peveril of the Peak' *
Canvas : 97 × 129.5
Signed : J.Pettie
Lent by the Trustees of the Orchar Art Gallery

This picture, exhibited at the RA in 1887, is an illustration to Scott's novel *Peveril of the Peak*. The episode depicted takes place just after the restoration of Charles II. The hero, Julian, son of a Cavalier, is playing with his companion Alice, the child of a Presbyterian neighbour, in the 'gilded chamber', a

JOHN PETTIE

107 Bonnie Prince Charlie entering the ballroom at Holyrood
Canvas : 158.8 × 114.3
Signed : J.Pettie
Lent by Her Majesty the Queen

Pettie's imagination worked best on situations that were overtly dramatic or which evoked what Stevenson has described in connection with Holyrood as 'the old radiant stories . . . the splendour and crime, the velvet and bright iron of the past.'

After Prince Charles had routed the English at Prestonpans, and before he himself was defeated at Culloden he held court at Holyrood. Scott in his first novel, *Waverley*, provides a description of the ball held at Holyrood, where the ladies 'espoused the cause of the gallant and handsome Prince, who threw himself upon the mercy of his countrymen, rather like a hero of romance than a calculating politician'. This is the atmosphere Pettie has cast round his subject, cleverly blending elements of fact or association drawn from older paintings. The

Prince's features for instance, are a glamourised copy of his face as it appears in genuine portraits. The combination of the wig with his own curling chestnut hair is also authentic. There are echoes too of Raeburn's *Glengarry*, in the dark figures of Lochiel and McDonald of Clan Ranald to the rear. For the dramatic conception of the young hero stepping forward from the gloom, to meet the brilliant light that strikes his sash, star, and silk waistcoat, Pettie may have been indebted to a generalised recollection of Rembrandt's *Night Watch*.

The picture was first exhibited in 1892, at the Royal Academy, the same year in which Orchardson showed the *Napoleon on St Helena* (catalogue no. 108) and MacWhirter *June in the Austrian Tyrol* (catalogue no. 109), each in its own way an equally spectacular picture. The *Bonnie Prince Charlie* was reproduced, full page, in *The Illustrated London News* for 30 April of that year.

WILLIAM QUILLER ORCHARDSON

108 St Helena 1816. Napoleon dictating to Count Las Cases the account of his campaigns
Canvas : 125 × 204.5
Lent by Merseyside County Council, Lady Lever Art Gallery, Port Sunlight

This was exhibited at the Royal Academy of 1892. It was Orchardson's second picture showing Napoleon after defeat and capture, the first being

Napoleon on board the Bellerophon of 1880. In choosing a subject from the history of his own century, and in treating it as a psychological rather than an overt physical drama, Orchardson was following directly in the footsteps of Wilkie who had in 1836 painted the confrontation between Napoleon and the Pope (now National Gallery of Ireland), representing it as a collision of wills or the clash of temporal and spiritual powers. Orchardson's use of empty space and the off-centre positioning of Napoleon suggests the influence, from a very long way back, of Pettie's *Cardinal Wolsey*, and *Gambler's Victim* both of 1869 (catalogue nos. 73 and 74), for Pettie was exploiting this kind of composition, to focus the viewer's attention upon the emotional predicament of a ruined man quite some time before Orchardson took it up. In Orchardson's *St Helena* the art of leaving out everything extraneous is brilliantly managed – in the near monochrome colouring, the bareness of the room, the extraordinarily evocative, almost cartoon like silhouette of Napoleon, and the great carpet of European maps that provide a still life as superb in its execution as it is effective in dramatic point. Orchardson's *St Helena* prompted several sentimental imitations by artists who lacked his irony and detachment. Francois Flameng's *C'est lui, Campagne 1814*, exhibited in 1893, shows a pot bellied Napoleon asleep in an inn kitchen, gaped at by soldiers, children and neighbours. Harold Piffard's *Last Review* of 1897 is even worse – a fat dying Napoleon gazing at some pretty children dressed as soldiers who are playing in his room. In contrast to the domination of the anecdotal element in these, Orchardson's subject is inherent in his artistic arrangement. His primarily aesthetic motivation was recognised by one reviewer who described the picture as 'a gaunt, bare room, a study in grey'.

JOHN MacWHIRTER

109 June in the Austrian Tyrol
Canvas : 123.8 × 185.4
Signed: MacW
Lent by the Trustees of the Tate Gallery

This was exhibited at the RA in 1892, the year of Orchardson's *St Helena* (catalogue no. 108) and Pettie's *Bonnie Prince Charlie* (catalogue no. 107). The *Illustrated London News* wrote that it 'blazes with flowers and bright grass, while in the distance the snow on the jagged ridge of mountains shows how near the extremes of climate are together in the lovely upland.'

MacWhirter was a great traveller, especially in the mountainous regions of Norway, Austria, and Italy, and many of his pictures were based on scenery drawn abroad. He shared a taste for the spectacular with Peter Graham that distinguishes his landscape painting from that of Chalmers or McTaggart.

109

WILLIAM McTAGGART

110 'Away o'er the sea' – Hope's whisper
Canvas : 94 × 145
Signed: W. McTaggart 1889
Lent by Kirkcaldy Art Gallery

110

This peaceful, luminous picture, with its smooth sea spreading out to the far distance, was painted in the same year as *The 'dark' Dora* (catalogue no. 118) and only a year before *The storm* (catalogue no. 111). The great range and variety of tone, colour and brushwork that these three pictures encompass, show the artist engaged in working out his own form of expressionism, the key element in his expressive language being the character of the individual brushmark. The impulse away from the recording of perceptual fact in art towards the rendering of personal feeling, can be seen taking place on the Continent at exactly the same moment, in the work of Van Gogh, Gauguin and Seurat, though McTaggart, unlike these artists, seems not to have felt the need for any theoretical or intellectual justification of his practices.

WILLIAM McTAGGART

111 The storm
Canvas : 121.9 × 183
Signed and dated: W. McTaggart 1890
National Gallery of Scotland

There is a small sketch either for, or after this, dated 1890, belonging to the Trustees of the Orchar Art Gallery. Both were based on an earlier picture of medium size painted out of doors at Carradale in

1883 (Kirkcaldy Art Gallery). The large version was painted in the studio, and follows the Kirkcaldy picture closely though the overall proportions are slightly different. Otherwise the main differences lie in the more diffused effect of the large picture and the reduction in the emphasis on the narrative element. The various onlookers sprawled on the foreground bank, or assisting in the launching of the rescue boat in the centre, who are only picked out gradually as one looks at the late version, are more positive presences in the 1883 picture.

and MacWhirter's 1892 *June in the Austrian Tyrol* (catalogue no. 109) shows how far the styles of McTaggart and his fellow student had now parted company.

WILLIAM McTAGGART

112 Blithe October *
Canvas : 148 × 115
Signed : W. McTaggart
Lent by the Duchess of Buccleuch

111

It has recently been convincingly suggested (by George Buchanan in *Scottish Art Review* Vol. xv, No. 2, 1979) that in the first version of *The storm* McTaggart was painting under direct impressionist influence. The second version of *The storm*, however, makes no pretence to naturalism of lighting of the kind the Impressionists sought, but is concerned with expressing the force and power of the elements, and the very cursory treatment of the figures increases the spectator's sense of their fragility and helplessness. Comparison between the 1890 *Storm*

113

This was exhibited at the RSA in 1893. It is a view of the artist's back garden at Broomieknowe, with his studio on the right. Neither the birch tree, which features in other pictures, nor the studio building, are still standing. A small version of the same picture is in the collection of the artist's family.

WILLIAM McTAGGART

113 North Berwick Law from Cockenzie *
Canvas : 65 × 123
Signed: W. McTaggart
Lent by Kirkcaldy Art Gallery

Like *Noontide Jovie's Neuk* (catalogue no. 114) this picture, also of 1894, is painted on a buff-coloured ground which has been left bare in places and used in a positive way to provide an intermediate unifying tone between the extremes of light and dark. The vigorously contrasted streaks and dashes of paint, which express the blustery, turbulent weather, are very different from the calm, parallel horizontals and luminous overall tone of *Noontide Jovie's Neuk.*

WILLIAM McTAGGART

114 Noontide, Jovie's Neuk
Canvas : 88.9 × 97.8
Signed: W. McTaggart
Lent by the City Art Centre, Edinburgh

Like catalogue no. 113, and several other pictures of a similar date, this work of 1894 is painted on a buff ground. Two quite distinct types of brushwork are used, one for the sky, the other for the plane of sea and land – the two halves being unified by colouring. In this picture McTaggart's tendency to paint 'ghost' figures and objects through whose outlines the background can be viewed, is carried very far. T. S. Robertson, who had worked under his tuition, wrote that McTaggart 'liked suggestions of things in preference to whole representations of them so that the imagination of those who looked at the picture might be exercised in filling up the unseen.' This may not be the whole explanation, for these 'suggestions' of figures also imply movement, and by their lack of detail and definition prevent the viewer from concentrating on them to the exclusion of interest in the landscape as a whole.

114

THOMAS GRAHAM

115 The landing stage
Canvas : 31.7 × 53.6
Lent by the Victoria & Albert Museum, London

115

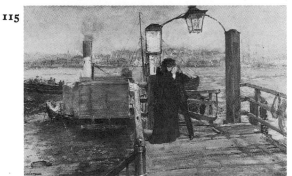

No picture of this title seems to have been exhibited by Graham, but in the early 1890s he was showing works of similar sounding subjects – The *Last boat*, *Adieu*, *Last words – Tyneside*, and *Harbour steps* – and this picture probably dates from the same period. The use of opaque pastel colours, especially the fresh blues, suggests some acquaintance with French painting, perhaps Boudin. This yielding to French influence separates Graham's treatment of family affection in a contemporary setting from the more traditional Wilkie derived form of presentation to which Orchardson adhered e.g. in *Her mother's voice* (catalogue no. 116).

WILLIAM QUILLER ORCHARDSON

116 Her mother's voice
Canvas : 123.9 × 185.4
Lent by the Trustees of the Tate Gallery

116

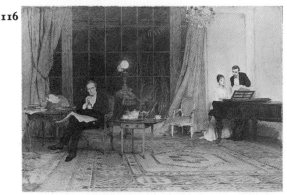

In the 1880s and the 1890s Orchardson worked on a number of pictures with contemporary subjects. All were concerned with family or marital relationships. All were psychological studies with a very delicate balance and a certain enigmatic or open ended character that leaves the outcome of the situation in doubt and the situation itself convertible to the viewer's own interpretation. All are presented with the detachment that is typical of Orchardson, and they represent in his work the culmination of the 'classical' Wilkie method of constructing a model of human behaviour, as seen in *Distraining for Rent* or the *Letter of Introduction*. *Her mother's voice* seems to depict a train of thoughts or memories roused in the mind of the elderly man, left, by his daughter's singing. The interior furnishings are used with economy and elegance to place the characters socially and distance them from each other mentally. The painting can also be viewed, independently of its ostensible subject, as a large still life, or as a study in artificial light effects – in this way it resembles Pettie's *Gambler's Victim* (catalogue no. 73). In 1888, the year in which *Her mother's voice* was exhibited at the RA, Claude Calthrop showed a painting of an almost identical subject *His favourite song*. The resemblances between the two works are far too close for coincidence and indicate that one or both of these artists were aware of what the other was doing. Orchardson's painting seems also to have influenced a rather similar work by Frank Dicksee, painted a few years later. In this, *A reverie* of 1895, the pianist, lamp, and reflective man are present in a re-arranged form, while behind the female musician hovers a spectral or angelic being which presumably represents the subject of the man's reverie. Neither in the Calthrop nor the Dicksee is Orchardson's lighthandedness with his subject matter apparent. Calthrop is prosaic, Dicksee overtly sentimental.

Armand Dayot (*La peinture Anglaise* 1908), criticised Orchardson for his tendency towards a symmetrical arrangement that gave his work a theatrical quality, citing the 'Voix de la mère' as an example.

WILLIAM QUILLER ORCHARDSON

117 Mariage de Convenance – After! *
Canvas : 113 × 169
Signed and dated: W. Q. Orchardson 1886
Lent by Aberdeen Art Gallery and Museums

This is the second part or sequel to Orchardson's *Mariage de Convenance* of 1883 (Glasgow City Art Gallery). The first picture shows a semi-estranged couple parted by an inordinately lengthy dining table. *After* provides a glimpse of the elderly husband when his wife has departed. There is considerable pathos in his frail stooping figure, deserted in a huge, magnificent, and extremely gloomy dining room, and the picture contains, in the decanter and stand of dessert on the tablecloth, one of the most exquisite pieces of still life ever painted by Orchardson – a dual purpose piece of still life which, as is usual with this artist, can be enjoyed either as a passage of pure painting, or interpreted as a description of character and situa-

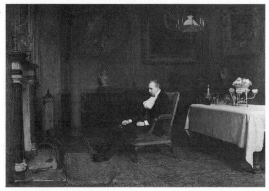

tion. Here the remnants of the solitary meal emphasise their owner's wealth and loneliness. Only the beauty and restraint of Orchardson's technique could make one forget what a banal pictorial cliché this sort of thing had become by the 1880s and look at it as something novel and affecting.

WILLIAM McTAGGART

118 The 'dark' Dora
Canvas : 82.5 × 73.5
Lent by Mrs E.F.McTaggart

This is a late version of the artist's Diploma work with the evening lighting that he painted out of the first picture (see catalogue no. 60). Exactly twenty years separate the *Dora* of 1869 from this version of 1889, and during that period the artist's conception of painting had undergone radical changes. The depiction of dusk in the first *Dora* probably bore a nearer resemblance to the carefully worked *Going to sea* (catalogue no. 43) than to the heavy expressionist use of brown pigment in this late version. As with many of the artist's late works a little time is needed in looking at it before the full subtlety of the atmospheric and spacial effects, and the delicate and poignant delineation of Dora's face gather themselves together out of the superficially incoherent swirls and streaks of paint. The time of day and dark tonal key are unusual in McTaggart's work. They are however paralleled by the more or less contemporary efforts of Orchardson in his *Mariage de Convenance – after!* of 1886 (catalogue no. 117) and *Solitude* (catalogue no. 120). Dusk subjects and low keyed pigments were in vogue generally towards the end of the century, but McTaggart stands apart from the London artists in the means he uses to provide an equivalent in paint for the effect of dusk on the viewer's eye and emotions. Nothing might seem so unpromising, even perverse, as McTaggart's heavy impasto and opaque brown, by which nevertheless the vast spaces of the dark field are mysteriously implied. This intense picture illustrates, far more clearly than McTaggart's bright daytime scenes, how far his art was from being an impressionist reconstruction of the laws of optics and natural lighting.

WILLIAM QUILLER ORCHARDSON

119 The feather boa, or Lady in a brougham
Canvas : 25.8 × 19.5 (sight size)
Lent by the Trustees of the Orchar Art Gallery

This is 'drawn' in paint as thin and translucent as watercolour. The fur and coat are rendered without any opaque pigment, simply allowing the canvas priming to show through. It relates to *Solitude* (catalogue no. 120) but the head is here seen against a light ground rather than a dark one.

WILLIAM QUILLER ORCHARDSON

120 Solitude *
Canvas : 57.8 × 77.5
Lent by Andrew McIntosh Patrick

From late 1890s onwards Orchardson was working on two subjects from contemporary life depicting the loneliness of widows. Neither picture was completed. *The Widow* which exists in a sketched or rubbed in form shows a woman seated alone at her breakfast table and appears to be closely based on F.D.Millet's *Widow* (RA exhibition of 1891). The other subject exists in three slightly different unfinished versions or sketches, of which this *Solitude* is one – and also in a small study of a woman's head (catalogue no. 119). All three versions of *Solitude* portray the widow seated alone in her carriage at dusk, and in this they resemble the painful isolation of *Dora* in the harvest field as painted by McTaggart only three years earlier, in 1889. In all versions of *Solitude* the darkness is used as a means to focus the viewer's attention upon the sad contemplative face of the widow. The version which belonged to Lord Blyth in 1913 also contained a carriage lamp which provided the light source on the woman's face.

THOMAS GRAHAM

121 Alone in London *
Canvas : 56.5 × 91.4
Signed: T.Graham
Lent by Perth Museum and Art Gallery

It is not possible to date this picture unless it can be identified with *The evening star* of 1904. The subject of girls on London bridges or standing on the Embankment had been employed from the 1840s onwards, by many painters interested in conveying salutary moral messages about female victims of poverty or social corruption and neglect. No such intention seems to have entered Graham's head. His painting is one of wistful and melancholy mood, perhaps coloured by Whistler's Thameside *Nocturnes*, and his interest in the theme of the lonely meditative woman in the dusk, is paralleled by McTaggart's *'Dark' Dora* of 1889 (catalogue no.

118) and Orchardson's *Solitude*, begun in the 1890s (catalogue no. 120), though each of these three artists employed quite different means to express the dusky atmosphere.

120

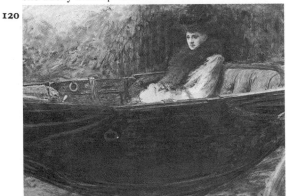

121

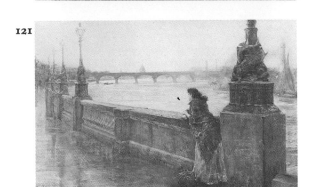

WILLIAM QUILLER
ORCHARDSON

122 The last dance
Canvas : 96.5 × 142
Lent by The Hon Alan Clark MP

This unfinished painting was begun in 1905 and is thus contemporaneous with McTaggart's, possibly unfinished, *Autumn evening, Broomieknowe* (catalogue no. 123).

For Orchardson, one can see, the chief expressive elements were the faces – or rather the heads – in their main relations to each other across the canvas. The surrounding space begins to come into existence only where it is contiguous to the heads or the bodies of the figures. His approach was thus exactly the reverse of McTaggart's, whose figures are components – not immediately even

122

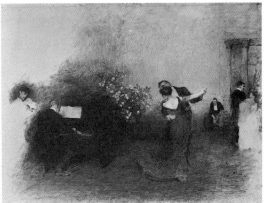

123

discernable as human – of the space they occupy. Orchardson's method of procedure was the same as that of Wilkie, whose unfinished *Knox dispensing the Sacrament*, had been an early influence on his *Wishart* (catalogue no. 42). Almost the only element common to late Orchardson and McTaggart is the white ground, used by both as a means of retaining luminosity.

Orchardson's subject belongs amongst his late group of scenes from modern life, especially those with melancholy subjects – for example Aberdeen's *After!* (catalogue no. 117), and *The Widow*. The emotional impact of couples leaving a room together had already been tried out by him in the much earlier Regency dance scene, *A social eddy*, of 1878.

A drawing for the composition is in the NGS collection.

WILLIAM McTAGGART

123 Autumn evening, Broomieknowe
Canvas : 101 × 162
Lent by the Trustees of Miss Jean McTaggart

This very late work of circa 1905 is said by the artist's family to be unfinished. Certainly it has not been signed, but McTaggart had by now reached a point where the question of finish cannot be decided by the quantity of paint or of bare canvas that are visible, or the amount or lack of detail, or any other simple test of this kind. In a sense the picture is complete – even though the artist may have intended to work at it again – and probably it always had a certain completeness, even at a much earlier stage in its making. It seems clear that McTaggart – unlike Orchardson whose *Last dance* (catalogue no. 122), is unfinished in the conventional meaning of the term – advanced his canvas as a unit, so that the space represented gradually materialised in all its parts, rather than appearing piecemeal, with here a completed tree, there a haystack or wall, and gaps of untreated canvas between.

The view is from the artist's home at Broomieknowe, and the gentle, silvery twilight is one of the most successful of his attempts in late life to paint the mood engendered by, and the quality of, a particular form of light.

SOME PORTRAITS OF LAUDER AND HIS PUPILS

JOHN HUTCHISON

124 Portrait head of Robert Scott Lauder
Marble : 41 × 33 approx.
Lent by the family of the artist

John Hutchison (1833–1910) sculptor, was one of Lauder's pupils at the Trustees' Academy. This portrait head had been intended for Lauder's tomb in Warriston cemetery, but was not placed there, since the marble turned out to be flawed. A replica was carved by Hutchison, which was set up in 1870, and is still in Warriston cemetery. The likeness was probably based on the plaster, and marble busts of Lauder, which Hutchison exhibited at the RSA in 1860, and 1862.

GEORGE PAUL CHALMERS

125 Self-portrait *
Panel : 24.8 × 17.8
Signed: G.P.Chalmers
Lent by the Royal Scottish Academy

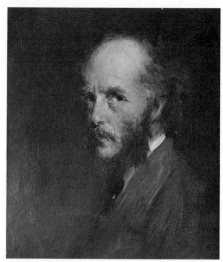

125 detail

GEORGE PAUL CHALMERS

126 Self-portrait *
Panel : 26.4 × 23.5
Lent by the Royal Scottish Academy

GEORGE PAUL CHALMERS

127 Self-portrait *
Panel : 25.4 × 20.3
Signed in monogram: G.P.
Lent by the Royal Scottish Academy

THOMAS GRAHAM

128 Portrait of W.Q.Orchardson
Canvas : 34.3 × 43.2
Signed: T.Graham
Lent by the Royal Scottish Academy

This was painted in 1890.

GEORGE PAUL CHALMERS

129 Portrait of John Pettie
Canvas : 61 × 48.3
Signed and dated: G.P.Chalmers / 62
Lent by the Royal Scottish Academy

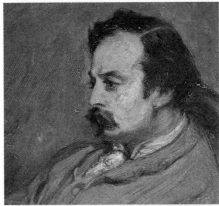

128
detail

130
detail

129
detail

JOHN PETTIE

133 Portrait of John MacWhirter *
Canvas : 34.5 × 29
Signed and dated: J. Pettie / 1882
Lent by Aberdeen Art Gallery and Museums

133
detail

This portrait was painted by Chalmers before Pettie went to London.

JOHN PETTIE

130 Portrait of the artist
Board : 30.5 × 24.5
Lent by the Trustees of the Tate Gallery

This portrait belonged to Pettie's friend and fellow student, MacWhirter, and hung in MacWhirter's library, in the company of portraits of Tom Graham and Peter Graham. MacWhirter also owned a portrait of himself by Pettie.

THOMAS GRAHAM

131 Portrait of Sir William Quiller Orchardson
Canvas : 51 × 61
Signed : T. Graham
Lent by Aberdeen Art Gallery and Museums

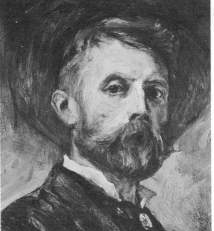

134
detail

WILLIAM QUILLER ORCHARDSON

132 Self-portrait *
Canvas : 34.5 × 29.5
Signed : WQO
Lent by Aberdeen Art Gallery and Museums

THOMAS GRAHAM

134 Self-portrait *
Canvas : 34.5 × 29.5
Signed and dated: T. Graham / 82
Lent by Aberdeen Art Gallery and Museums

ROBERT HERDMAN

135 Self-portrait *
Canvas : 34.5 × 30
Signed with monogram and dated : 83
Lent by Aberdeen Art Gallery and Museums

135
detail

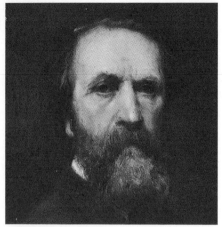

JOHN PETTIE

136 Self-portrait *
Canvas : 34.5 × 29.5
Signed and dated : J. Pettie / 1881
Lent by Aberdeen Art Gallery and Museums

JOHN PETTIE

**137 The Warrior: self-portrait in 16th century
armour ***
Canvas : 62 × 41
Signed : J. Pettie
Lent by Aberdeen Art Gallery and Museums

137
detail

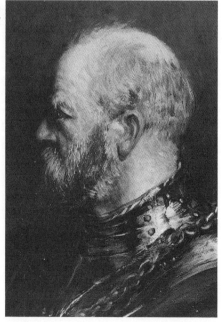

136
detail

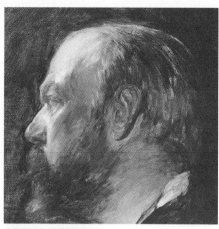

JOHN BURR

138 Self-portrait *
Panel : 31.2 × 23.8
Signed : J. Burr
Lent by Aberdeen Art Gallery and Museums

Though this portrait is undated, the sitter's youthful appearance suggests it was painted in the late 1840s or early 1850s.

138
detail

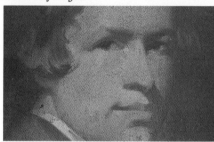

139
detail

GEORGE PAUL CHALMERS

139 Self-portrait
Canvas : 31.7 × 25.4
Scottish National Portrait Gallery

GEORGE PAUL CHALMERS

140 Portrait of John Pettie
Millboard : 25.4 × 18.7
Scottish National Portrait Gallery

140
detail

JOHN PETTIE

141 Portrait of Chalmers
Canvas : 61.6 × 51.4
Scottish National Portrait Gallery

This was painted in 1862.

JOHN PETTIE

142 Portrait of Orchardson
Canvas : 40.6 × 35.5
Scottish National Portrait Gallery

142
detail

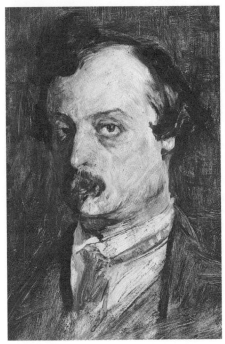

143
detail

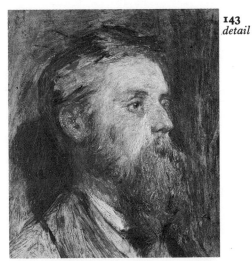

WILLIAM QUILLER ORCHARDSON

143 Portrait of Thomas Graham
Canvas : 40.6 × 35.5
Scottish National Portrait Gallery

JOHN BURR

144 Self-portrait
Canvas : 45.7 × 38.1
Scottish National Portrait Gallery

PETER GRAHAM

145 Self-portrait *
Canvas : 34.5 × 29.7
Lent by Aberdeen Art Gallery and Museums

145
detail

Appendices

THE TRUSTEES' ACADEMY: CHRONOLOGY OF MAIN EVENTS
1760–1861

1760
The Board of Trustees for the Encouragement of Manufactures in Scotland starts a Drawing Academy with William Delacour as Master. Rooms in the Old College are lent by the University. Tuition is free to both sexes.

1765
Charles Pavillon succeeds Delacour as Master.

1772
Alexander Runciman succeeds Pavillon as Master.

1786
David Allan succeeds Runciman as Master.

1790
The Academy moves to the Mint Court.

1797
John Wood succeeds David Allan as Master.

1798
John Graham is appointed joint Master with Wood. The Trustees spend £50 on casts of the antique.

1800
John Wood is dismissed as a fraud. The Academy moves to David Martin's old studio in St James' Square.

1806
The Academy moves to Picardy Place where the Trustees build a Gallery and a Keeper's residence.

1816
Casts of four pieces of the Elgin Marbles are bought by the Trustees.

1818
Andrew Wilson succeeds Graham as Master.

1822
Robert Scott Lauder enters the Trustees' Academy as a student.

1826
William Allan succeeds Andrew Wilson as Master. The Academy moves into the Royal Institution Building on the Mound (now the RSA).

1829–30
Robert Scott Lauder deputises as Master during Allan's absence on sick leave.

1837
William Dyce and Charles Heath Wilson are appointed by the Board to start a new Class for

Design. Their proposals are published as a *Letter to Lord Meadowbank*. Dyce does not take up his post and the class is run by Wilson alone.
Charles Heath Wilson's *Descriptive Catalogue of the Casts from Antique Statues in The Trustees' Academy* is published.

1838
Thomas Duncan is appointed to a new department of Colour at the Academy.

1842
James Miller's *Introductory lecture on Pictorial Anatomy* to the students, is published.

1843
David Scott offers himself as a candidate for the Directorship of the Trustees' Academy. Is rejected.

1844
William Allan resigns. Thomas Duncan is appointed Director, assisted by William Crawford and John Ballantyne.

1845
Death of Duncan. He is succeeded by Alexander Christie as Director.

1851
Sir John Watson Gordon notices a deterioration at the Academy. The Trustees appoint him Convener of a Committee to investigate the matter.

1852
Robert Scott Lauder is appointed as Director of the Antique at the Academy at the recommendation of the Committee. Christie remains Director of the Design classes.

1856–57
Fees are introduced by the Trustees for the first time.

1858
By a Treasury Minute the Academy is divided, the Board retaining the Design and Antique classes, which are affiliated with the Department of Science and Art, and the Royal Scottish Academy taking over the Life class. Paton, Drummond, and Archer report to the RSA on *The mode of conducting the study of the living model*.

1859
The RSA opens its Life class.

1860
Death of Alexander Christie.

1861
Lauder is incapacitated by a stroke and ceases to teach.

BRIEF BIOGRAPHIES OF LAUDER'S PUPILS

Alexander Hohenlohe Burr 1835–99
Brother of John Burr. Born Manchester. Entered the Trustees' Academy in 1848 and returned in 1854 after Lauder's appointment. First exhibited RSA 1856. First exhibited RA 1860. Went to London 1861. Genre painter of country scenes in the tradition of Wilkie, Geikie, and Tom Faed.

John Burr 1831–93
'*A bluff, jolly Scotchman, bristling with anecdote and improbable stories, with a resonant voice and a hearty laugh.*'
Entered the Trustees' Academy 1849. Returned in 1854 to join Lauder's class. First exhibited RSA 1856, and RA 1860. Moved to London 1861. Became an Associate of the Old Water-Colour Society, and President of the Royal Society of British Artists. Specialised in genre scenes of cottage life and scenes of childhood, often with a humorous edge.

Hugh Cameron 1835–1918
Born Edinburgh. Entered Trustees' Academy 1849 as an architectural student. Moved into Lauder's class 1852. 1854 won first prize for drawing from the antique, and first exhibited at the RA. 1859 made Associate of the RSA, and RSA in 1869. First exhibited at RA 1871. 1876–88 lived in London. Mainly a genre painter, choosing scenes of childhood and country life, and preferring a soft, pastel range of colours. His early work shows Pre-Raphaelite influence, his later, the influence of the French Barbizon painters. In feeling it often verges on the sentimental.

George Paul Chalmers 1833–78
'*In the case of Chalmers the seeming inconsistencies become explicable as we think of the man, and recall his strangely dual character. From one side he seemed strong and manly, with vigour corresponding to his well knit frame; but on the other side he was nervous and impressionable as a woman.*'
Born Montrose. Entered Trustees' Academy 1853. First exhibited RSA 1860. Made Associate of the RSA 1867, and RSA 1871.
Chalmers was mainly a figurative painter who took up landscape painting during the last part of his life. He was a highly spontaneous, intuitive artist who left many canvases unfinished and destroyed others in fits of despondency when his work went badly. His career was tragically cut short by his murder, in 1878.

Peter Graham 1836–1921
'*On account of . . . a constitutional shyness of strangers, he has personally shunned the public gaze. . . . In the summer season, of course, Mr Graham, as a landscape artist, spends a large part of his time in the open air. Neither heat, nor wet, nor exposure to the elements, seem to have in all these years much affected Mr Graham's wiry and active frame.*'
Born in Edinburgh, entered the Trustees' Academy in 1850. First exhibited at the RSA in 1855. 1860 made Associate of the RSA. 1866 first exhibited at the RA, and moved to London. 1877 made Associate of RA, and RA in 1881. He divided his time between his home in Notting Hill and country studios, first at Gerrard's Cross, later at St Andrews. Specialised in landscape and coastal scenes of a wild and desolate nature.

Thomas Graham 1840–1906
Born at Kirkwall. Entered the Trustees' Academy 1855. 1859 first exhibited at RSA. 1863 first exhibited at RA, and went to London. 1883 made an Hon. Member of the RSA. Genre, historical, and portrait painter. Graham's paintings are gentle and sensitive, sometimes showing the influence of his rather stronger fellow student, Orchardson to whom he was devoted.

Robert Herdman 1829–88
Born Rattray. Educated at St Andrews University. 1847 entered the Trustees' Academy. Returned 1852. Won first prize for painting from the life in 1849–50 session. 1850 first exhibited at RA. 1855 visited Italy. 1858 made Associate of the RSA, and RSA in 1863. 1862 first exhibited at RA.
Herdman was mainly a figurative painter of genre, and historical scenes, and produced a number of paintings dealing with the life of Mary Queen of Scots.

William McTaggart 1835–1910
Born in the Laggan of Kintyre. Entered Trustees' Academy 1852. 1855 first exhibited at RSA. 1856 won first prize for painting from the life, and in 1857, first prize for painting from the antique. 1859 made Associate of the RSA. 1866 first exhibited at the RA. Made RSA 1870. 1889 moved to Broomieknowe, Lasswade.
Mainly a painter of sea and landscapes with figures. Probably the most outstanding and original of all Lauder's students, he pursued his own search for emotional and atmospheric truth in his landscape paintings in ways that are parallel to, but not imitations of contemporary artistic movements on the Continent. His art continued to develop until the end of his life.

John MacWhirter 1839–1911
'*Rugged and vigorous, a fine, handsome, large-hearted Scotchman, with the gentlest of manners, so strangely at variance with his big, rather rough exterior.*'
Born at Slateford, near Edinburgh. Entered the Trustees' Academy 1851. First exhibited at RSA 1854 and at RA 1865. Made Associate of the RSA 1867. Moved to London 1869. Visited America 1877. Made Associate of the RA in 1879, and RA in 1893. Some early flower studies attracted the

attention of Ruskin who bought and presented them to the School of Art at Oxford.

MacWhirter's speciality was landscape and he had a preference for wild mountain or forest scenery. He travelled considerably on the continent, especially in Norway, Austria, and Italy.

Sir William Quiller Orchardson 1832–1910

'He was always good-looking, so light-hearted and so clever in conversation. Occurrences that would have worried most people seemed only to amuse him.'

Born Edinburgh. Entered Trustees' Academy 1845. 1848 first exhibited at RSA. Won first prizes at the Trustees' Academy in sessions of 1849–50, 1850–51, and 1851–52. Returned to the Academy after Lauder's appointment. 1862 went to London. 1863 first exhibited at the RA. 1867 exhibited at the Exposition Universel and received a third class medal. 1868 made Associate of the Royal Academy. 1870 visited Venice. 1877 became RA. 1889 exhibited at the Exposition Universel and received a gold medal. 1895 made Chevalier de l'ordre de la Légion d'honneur. 1907 Knighted. Figurative painter mainly of historical scenes, and scenes from contemporary life. His pictures were highly organised in the placing and relating of figures, and in the decorative use of spaces between figures. He had a taste for exquisite and muted colour schemes.

John Pettie 1839–93

'Extraordinary blue eyes, a nondescript nose, fresh complexion, and friendly energetic ways; he simply radiated energy and kindliness.'

Born in East Linton. Entered the Trustees' Academy in 1855. 1857 received first prize for painting from the antique. 1858 first exhibited at the RSA, and 1860 first exhibited at the RA. Moved to London in 1862, made Associate of the RA in 1866, and RA in 1873. 1875 elected to the council of the RA. In 1882 built himself a neo-Georgian house in Fitzjohn's Avenue. Pettie specialised in dramatic historical subjects from the sixteenth, seventeenth, and eighteenth centuries. He had a particular admiration for the paintings of Rembrandt, Van Dyck, and Rubens.

SELECT BIBLIOGRAPHY

Manuscript Sources

PRIVATE COLLECTIONS

Lauder's Roman Journal, a presscuttings book concerned with his pictures (which either he or his wife must have assembled), and other manuscripts, consulted in preparing this catalogue, are in the possession of his descendants.

Letters to or from William McTaggart, Pettie, and George Paul Chalmers, consulted whilst preparing this catalogue, are in the possession of William McTaggart's descendants.

PUBLIC COLLECTIONS

Scottish Record Office, Register House. Most of the archives of the Board of Trustees for Manufactures in Scotland, have been transferred here by the National Galleries of Scotland. Documents include the Board Minutes, Letter Books, Reports, Student lists, and the Minutes of the Committee convened in 1851 by Watson Gordon. This material is fully catalogued by Register House under the no. NG I.

National Galleries of Scotland. A considerable amount of MS material, connected with the operations of the Board of Trustees in the 19th century, has only recently come to light here, and will probably be transferred to the Records Office in due course. Estimates of expenditure, draft reports, applications for admission to the Trustees' Academy, correspondence concerning the acquisition and transport of casts, and correspondence with the Royal Scottish Academy are included in this collection. It is unsorted and uncatalogued. Otherwise MS material at the National Gallery of Scotland consists of James Caw's notebooks, which he compiled while preparing his monograph on McTaggart – including his transcriptions of some of the privately owned family letters – a scrap and presscuttings book maintained by the Board from 1850 to 1873, and a photocopy of the Lauder family's presscuttings book. The Scottish National Portrait Gallery possesses a typed transcription of Robert Herdman's *Work Book 1870–87*.

Royal Scottish Academy. The library of the Royal Scottish Academy contains much documentary material concerned with relations between the Board and the RSA, especially during the critical year of 1858. There are also a number of letters from R. S. Lauder in London to D. O. Hill, and from Lauder in Italy to David Ramsay Hay. Simpson's own annotated transcriptions of G. P. Chalmers' letters to him, are also in the RSA library. Correspondence is catalogued under the year of production.

The National Library of Scotland. The original Chalmers MSS of his letters to Simpson are here, catalogued under MS 6348. There are a number of letters from R. S. Lauder to different correspondents, the most important being those to David Roberts (MS 7723). There is also a collection of David Roberts' letters to D. R. Hay written during the 1840s and 50s (MS 3521 and 3522), and to the Bicknells during the 1850s (MS 7723) – both of which contain frequent references to Lauder, his pictures and private affairs.

PUBLISHED SOURCES

William Dyce and Charles H. Wilson; *Letter to Lord Meadowbank . . . on the best means of ameliorating the arts and manufactures of Scotland in point of taste* Edinburgh 1837.

Anon; *Scottish Art and National Encouragement* Edinburgh and London 1846.

Anon; *R.S.Lauder* in *The Art Journal* 1850, pp. 12 and 13.

Address by Professor Thomas Stewart Traill at the delivery of prizes to the students of the school of design in Edinburgh Edinburgh 1854.

J. Noel Paton, James Drummond, James Archer; *Report by the Visitors on the mode of conducting the study of the living model* Edinburgh 1858.

Iconoclast; *Scottish Art and Artists in 1860* Edinburgh 1860.

Descriptive Catalogue of the Statue Gallery, Royal Institution, Edinburgh Edinburgh 1861.

L'Inconnu; *Landscape and Historical Art in the Royal Scottish Academy of 1862* Edinburgh 1862.

Science and Art Department of the Committee of Council on Education, South Kensington; *Art Director with regulations for promoting Instruction in Art* London 1865.

David Laing; *The Edinburgh School of Design in 1784* from the *Proceedings of the Society of Antiquaries of Scotland*, 11 January 1869.

Catalogue of the remaining works of George Paul Chalmers RSA T. Chapman and Son sale, Hanover Street, Edinburgh, 5 and 6 April 1878.

James Dafforne; *The Works of John MacWhirter ARSA* in *The Art Journal* 1879, pp. 9–11.

Alexander Gibson and John Forbes White; *George Paul Chalmers RSA* Edinburgh 1879.

Loan Exhibition of works by the late Sam Bough RSA and the late George Paul Chalmers RSA, Glasgow Institute of the Fine Arts 1880.

Alice Meynell; *Our living artists. William Quiller Orchardson RA* in *The Magazine of Art* Vol. IV, 1881, pp. 276–81.

Wilfrid Meynell; *Our living artists. John Pettie RA* in *The Magazine of Art* Vol. IV, 1881, pp. 11–16.

Wilfrid Meynell; *John Pettie RA* in *Some Modern Artists and their work* London 1883, pp. 196–202.

Robert Herdman; *Address to Art Students by the late Robert Herdman RSA*, Edinburgh 1888.

Edward Pinnington; *George Paul Chalmers and the art of his time* Glasgow 1896.

James Stanley Little; *The Life and Work of William Quiller Orchardson* in *The Art Annual* for 1897.

Cosmo Monkhouse; *William Quiller Orchardson RA* in *Scribner's Magazine* vol. XXI, April 1897, no. 4.

A. H. Millar; *The Collection of I. Julius Weinberg, Esq. of Dundee* in *The Art Journal* 1898, pp. 16–20 and 84–9.

Edward Pinnington; *Robert Scott Lauder RSA and his pupils* in *The Art Journal* 1898, pp. 339–343 and 367–71.

W. Mathews Gilbert; *The Life and work of Peter Graham RA* in *The Art Annual* for 1899.

Edward Pinnington; *William McTaggart RSA* in *Good Words* Nov. 1899.

P. M'Omish Dott; *Notes technical and explanatory on the art of Mr William McTaggart* exhibition catalogue, Edinburgh 1901.

Edward Pinnington; *Hugh Cameron RSA* in *The Art Journal* 1902, pp. 17–20 and 297–300.

Archdeacon Sinclair; *John MacWhirter RA* in *The Christmas Art Annual* 1903.

Sir Walter Armstrong; *The Art of William Quiller Orchardson* London 1905.

W. D. Mackay; *The Scottish School of Painting* London 1906.

Martin Hardie; *John Pettie RA* in the Spring Number of *The Art Journal* 1907.

James L. Caw; *Scottish Painting past and present* Edinburgh 1908.

Martin Hardie; *John Pettie* London 1908.

The Collection of the late Sir William Q. Orchardson RA, Gillows, Tuesday, 24 May 1910, and the three following Sale catalogue.

Sketches from Nature by John MacWhirter RA with an introduction by Mrs MacWhirter London 1913.

James L. Caw; *William McTaggart* Glasgow 1917.

Catalogue of a choice collection of Pictures by the late Hugh Cameron RSA, Edmiston's sale 13 May 1920.

James L. Caw; *Hours in the Scottish National Gallery* London 1927, pp. 44–53.

Hilda Orchardson Gray; *The Life of Sir William Quiller Orchardson* London 1930.

Sir James Caw; *Art Centenary. Sir W. Q. Orchardson* in *The Scotsman* 26 March 1932.

Sidney C. Hutchison; *The Royal Academy Schools 1768–1830* Walpole Society 1962.

David and Francina Irwin; *Scottish Painters at home and abroad* London 1975.

William Hardie; *Scottish Painting 1837–1939* London 1976.

ACKNOWLEDGEMENTS

It would have proved impossible to carry out the research necessary for this exhibition without the help and generous co-operation of a great many people. In particular I would like to thank, Miss Betty and Miss Nellie McTaggart, Mrs E. F. McTaggart, Miss Herdman, Dr and Mrs Taylor, Mr and Mrs Painter, Mrs Viles, Mr David Michie, Mr Ian Gow, Miss Helen Smailes, and Mr James Holloway.

LIST OF LENDERS

Her Majesty The Queen : 107
Her Grace The Duchess of Buccleuch : 112
The Hon. Alan Clark MP : 70, 122
Mr and Mrs Richard Emerson : 6
James Holloway : 7, 44, 71
Duncan MacMillan : 16
The Trustees of Miss Barbra McTaggart : 57
Mrs E. F. McTaggart : 118
The Trustees of Miss Jean McTaggart : 123
Mr and Mrs Robert Nilsson : 49
Andrew McIntosh Patrick : 120
Mrs M. Vaughan : 63
Private Collections : 8, 11, 12, 13, 14, 15, 25, 48,
 61, 62, 68, 100, 124
Aberdeen Art Gallery & Museums : 17, 56, 83, 86,
 98, 117, 131, 132, 133, 134, 135, 136, 137, 138,
 145
Angus District Museums : 64
Arbroath, The Patrick Allan-Fraser of Hospital-
 field Trust : 10, 29, 77
City of Dundee Art Gallery : 34, 58, 59
Dundee, The Trustees of the Orchar Art Gallery :
 41, 54, 69, 80, 81, 82, 84, 85, 87, 90, 91, 106, 119
Edinburgh, The City Art Centre : 114
Edinburgh, The Governors of Edinburgh College
 of Art : 32, 36, 37, 38
Edinburgh, Royal Scottish Academy : 4, 9, 60,
 125, 126, 127, 128, 129
Edinburgh, Scottish National Portrait Gallery : 1,
 5, 18, 19, 20, 21, 96, 102, 139, 140, 141, 142,
 143, 144
Edinburgh, The University : 22
Glasgow Art Gallery & Museum : 75, 97, 99, 104
Kirkcaldy Art Gallery : 43, 92, 93, 110, 113
London, The Fine Art Society : 40, 50, 89
London, The National Portrait Gallery : 2
London, The Trustees of The Tate Gallery : 109,
 116, 130
London, The Victoria & Albert Museum : 115
City of Manchester Art Galleries : 95
New York, The Forbes Magazine Collection : 28
Perth Museum & Art Gallery : 27, 55, 65, 121
Port Sunlight, Merseyside County Council, Lady
 Lever Art Gallery : 108
Sheffield City Art Galleries : 67, 74
St Andrews, The University : 42
Stirling, Stirling Smith Art Gallery & Museum :
 26, 66

ARTISTS' WORKS EXHIBITED

A. H. Burr : 46, 55, 59
J. Burr : 58, 83, 138, 144
H. Cameron : 45, 49, 56, 79, 82
G. P. Chalmers : 38, 52, 54, 64, 66, 69, 71, 78, 80,
 89, 90, 91, 96, 97, 98, 125, 126, 127, 129, 139,
 140
P. Graham : 72, 94, 145
T. Graham : 50, 51, 93, 115, 121, 128, 131, 134
R. Herdman : 61, 62, 63, 68, 135
J. Hutchison : 124
R. S. Lauder : 1-29
W. McTaggart : 37, 39, 40, 43, 53, 57, 60, 84, 85,
 87, 88, 92, 100, 103, 110, 111, 112, 113, 114,
 118, 123
J. MacWhirter : 71, 95, 109
Sir W. Q. Orchardson : 34, 35, 41, 42, 48, 65, 70,
 75, 76, 86, 101, 105, 108, 116, 117, 119, 120,
 122, 132, 143
J. Pettie : 44, 47, 67, 73, 74, 77, 81, 99, 102, 104,
 106, 107, 130, 133, 136, 137, 141, 142
R. Scott : 30, 31
W. B. Scott : 33
Unknown : 36